ILLUSTRATED

Symbols and Emblems

OF THE

JEWISH, EARLY CHRISTIAN, GREEK, LATIN, AND MODERN CHURCHES

By

H. J. SMITH

Philadelphia:

T. S. LEACH & COMPANY

29 NORTH SEVENTH STREET

1900

Printing Statement:

Due to the very old age and scarcity of this book,
many of the pages may be hard to read due to the
blurring of the original text, possible missing pages,
missing text and other issues beyond our control.

Because this is such an important and rare work, we
believe it is best to reproduce this book regardless of
its original condition.

Thank you for your understanding.

Preface

HE great increase of art schools throughout our country during the past ten years has added largely to the number of those who are able to justly appreciate and criticise art work. It has also added largely to the class that depend upon art occupations for a livelihood. But while these schools are thus elevating the art standard of our country, the subject of Symbolism seems to have been overlooked, and the graduates are left to learn or to guess at the meaning of the symbols that are used so lavishly in our churches.

The same want of instruction in this branch of art work is also painfully evident in art glass, tapestry, etc., that are brought into the country from abroad. I have seen in foreign work the pictured head of a saint surrounded with the cruciform nimbus, the pictured head of a female saint crowned with an arched crown, and the flaming torch on an art tablet commemorating the virtues of the deceased. Apart from these incongruities, the work commanded respect.

Why this general neglect? A search through our public libraries revealed many works on the subject, but

written by and for the theologian or the archæologist. The art student may be interested, but has not the time, when in search of information, to read them.

One may, after considerable labor, find about fifty different emblems illustrated in these works. I have endeavored to make the subject as plain and concise as possible, giving over three hundred and fifty illustrated symbols and emblems, their biblical or other foundation, and a few leading points of information about them, so that the clergyman, architect, illustrator, decorator, etc., may see at a glance what they require.

I had long wished that someone would write such a work, when it occurred to me that few had the facilities at hand that I possessed, my position demanding the almost daily use of these symbols.

The great majority of the illustrations have been used by me in actual work, and therefore have the approval of the clergymen of various denominations. The types are not arbitrary; the greatest latitude in regard to color is admissible in nearly all cases, but when heraldic devices are used, one cannot be too careful either in form or color.

H. J. SMITH.

PHILADELPHIA, PA., 1900.

The following authorities
have been mainly consulted in compiling this book:

OWEN JONES

A. A. DIDRON A. W. PUGIN

F. E. HULME, F.L.S. AND F.S.A.

The biblical quotations are from the King James Bible, except
those marked D, which are from the Douay Bible.

Designed, edited and illustrated
by
H. J. SMITH.

Illustrated
Symbols and Emblems
of the
Jewish, Early Christian,
Greek, Latin and Modern Churches

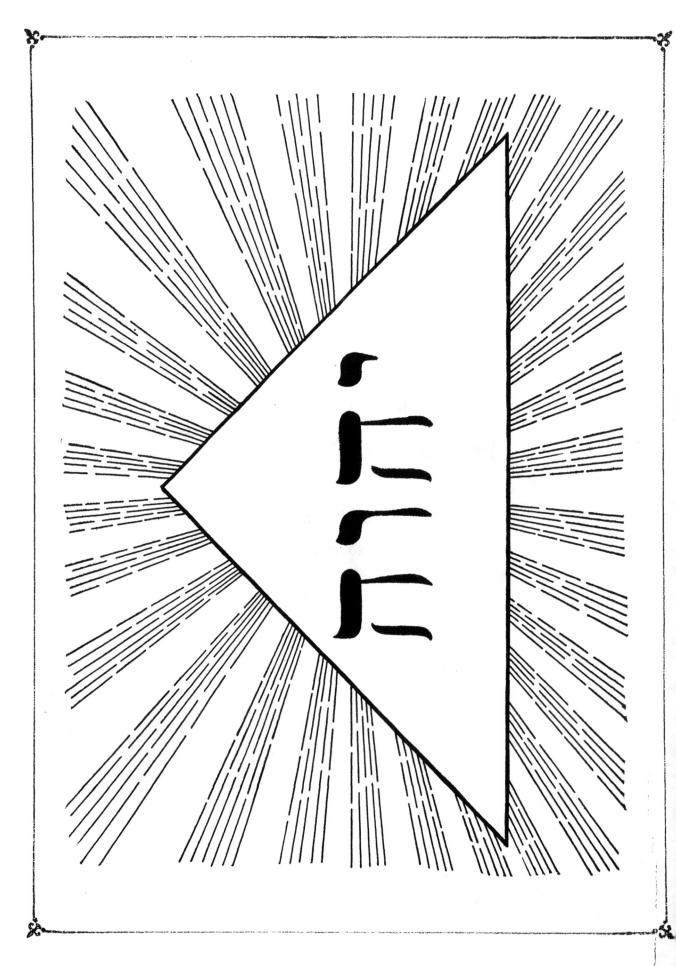

Plate I

SYMBOLS AND EMBLEMS

Symbol of the Jehovah

The triangle is the symbol of Jehovah in all churches, but with the letters (Jehovah) in centre is used only in Christian churches.

"And I appeared unto Abraham, unto Isaac, and unto Jacob, by the name of God Almighty; but by my name Jehovah was I not known to them."

Exodus vi: 3.

NOTE.—This form of triangle should not be used as an emblem of the Trinity. It does not denote equality.

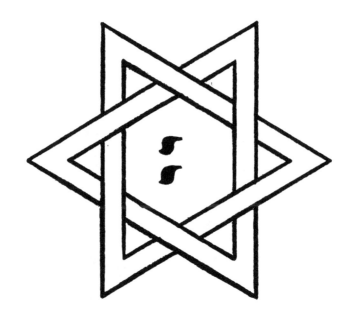

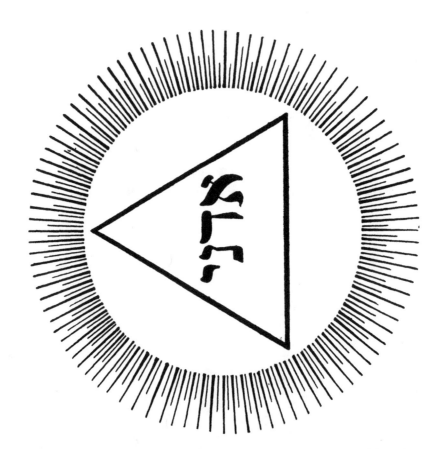

Plate II SYMBOLS AND EMBLEMS

I.

The double interlacing triangle is used in very many of the Jewish Synagogues, and is called the shield of David. The two Yods in centre are not part of the shield, but are sometimes placed as shown; they are also used in centre of triangle, and are an abbreviation of the word Jehovah, and are used by the Jews to express that word, on account of the prohibition to pronounce or write the word in full.

II.

Triangle containing the word LORD in Hebrew. Surrounded by rays in circle form. Emblematic of the Eternal Lord.

"And Abraham planted a grove in Beer-sheba, and called there on the name of the LORD, the everlasting God."

Genesis xxi : 33.

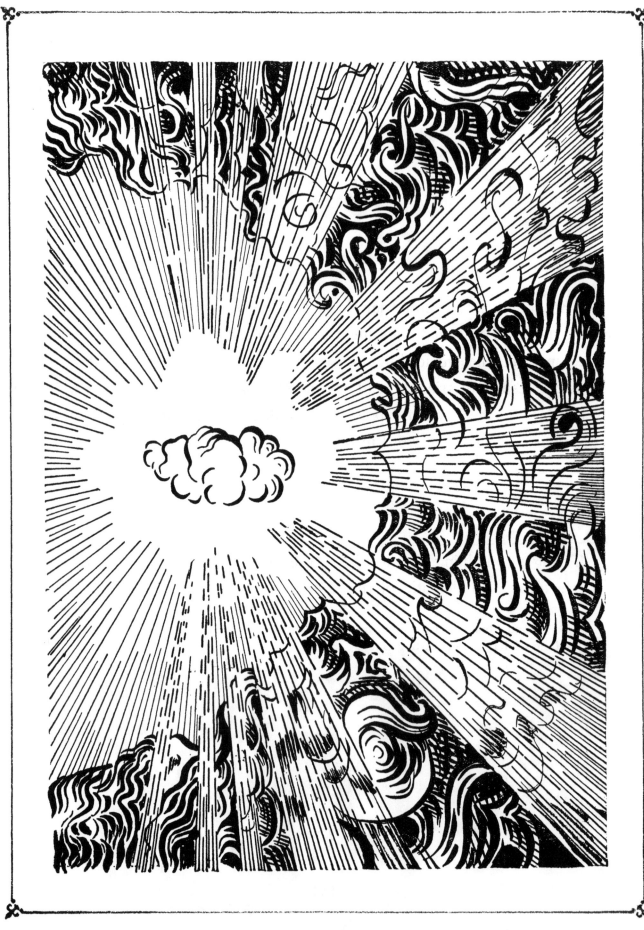

Plate III SYMBOLS AND EMBLEMS

First Day of Creation

"In the beginning God created the heaven and the earth.

"And the earth was without form, and void; and darkness was upon the face of the deep. And the Spirit of God moved upon the face of the waters.

"And God said, Let there be light: and there was light.

"And God saw the light, that it was good: and God divided the light from the darkness.

"And God called the light Day, and the darkness he called Night. And the evening and the morning were the first day."

Genesis i: 1-5.

The cloud is used here as the symbol of Jehovah.

"And the Lord came down in a cloud."

Numbers xi: 25.

"And the Lord descended in the cloud, and stood with him there, and proclaimed the name of the Lord."

Exodus xxxiv: 5.

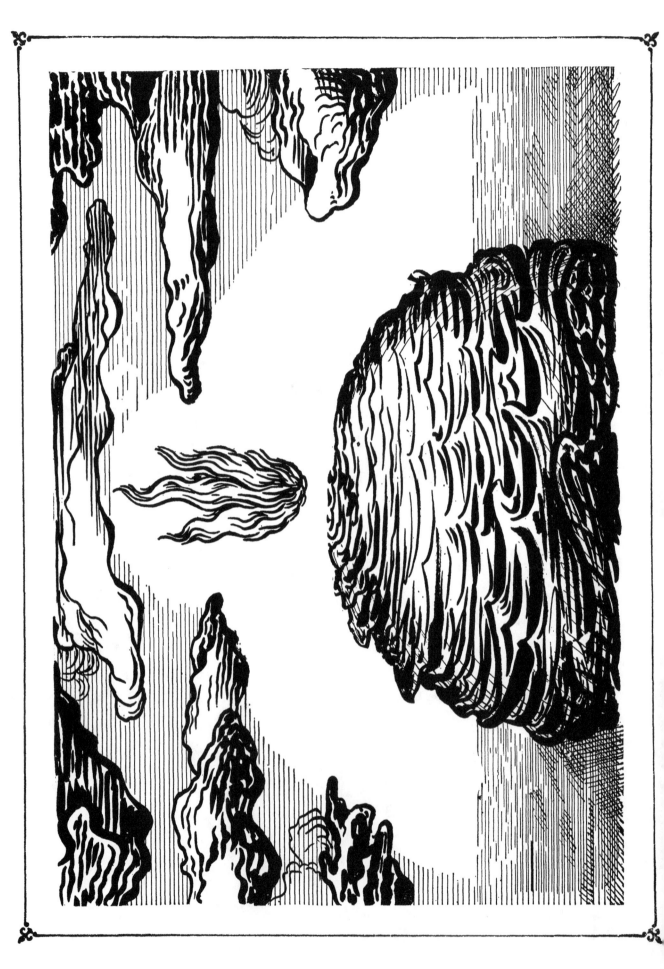

Plate IV SYMBOLS AND EMBLEMS

Second Day of Creation

"And God said, Let there be a firmament in the midst of the waters, and let it divide the waters from the waters.

"And God made the firmament, and divided the waters which were under the firmament from the waters which were above the firmament: and it was so.

"And God called the firmament Heaven. And the evening and the morning were the second day."

Genesis i: 6-8.

The flame is used here as a symbol of Jehovah.

"And the Lord went before them by day in a pillar of a cloud, to lead them the way; and by night in a pillar of fire, to give them light; to go by day and night."

Exodus xiii: 21.

"And I looked, and behold, a whirlwind came out of the north, a great cloud, and a fire infolding itself, and a brightness was about it."

Ezekiel i: 4.

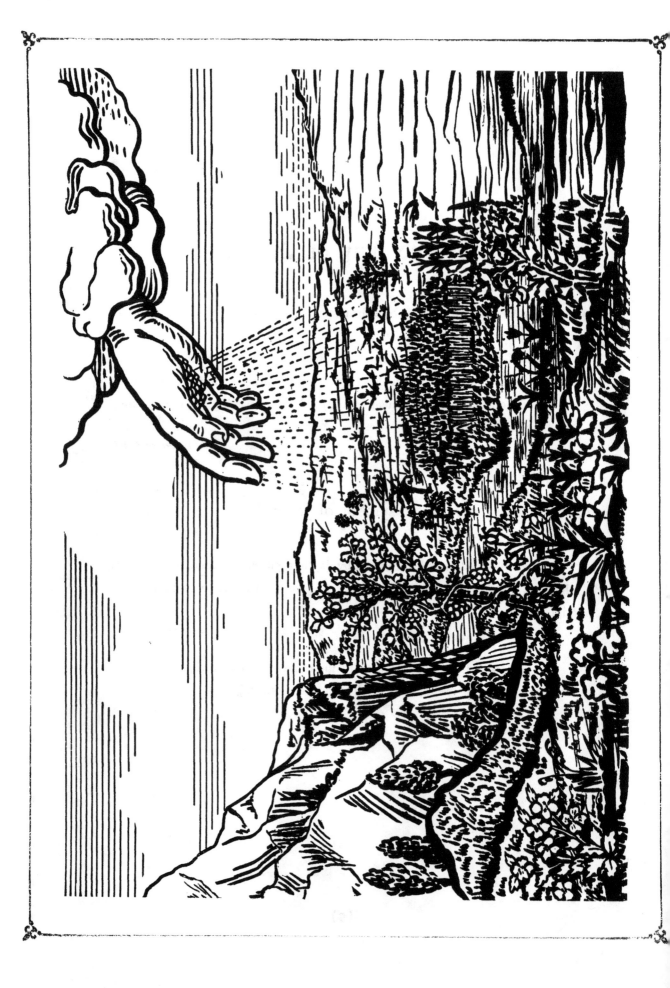

Plate V

SYMBOLS AND EMBLEMS

Third Day of Creation

"And God said, Let the earth bring forth grass, the herb yielding seed, and the fruit-tree yielding fruit after his kind, whose seed is in itself, upon the earth: and it was so.

"And the earth brought forth grass, and herb yielding seed after his kind, and the tree yielding fruit, whose seed was in itself, after his kind: and God saw that it was good.

"And the evening and the morning were the third day."

Genesis i : 11-13.

The hand is a symbol of the power of the Creator.

" There is nothing better for a man, than that he should eat and drink, and that he should make his soul enjoy good in his labour. This also I saw, that it was from the hand of God."

Ecclesiastes ii : 24.

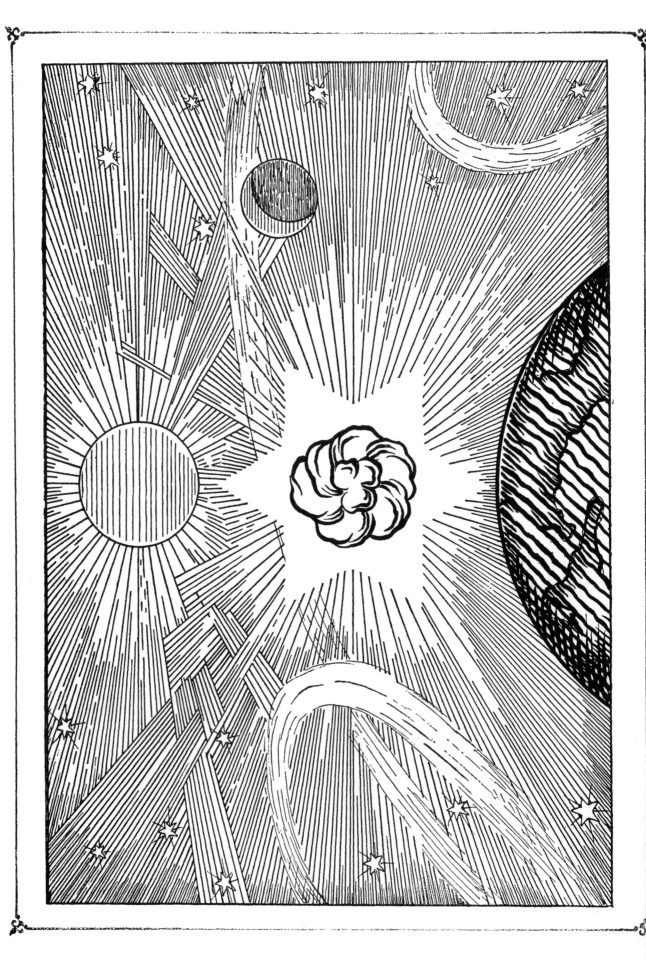

Plate VI SYMBOLS AND EMBLEMS

Fourth Day of Creation

"And God said, Let there be lights in the firmament of the heaven, to divide the day from the night; and let them be for signs, and for seasons, and for days and years:

"And let them be for lights in the firmament of the heaven, to give light upon the earth: and it was so.

"And God made two great lights; the greater light to rule the day, and the lesser light to rule the night: he made the stars also.

"And God set them in the firmament of the heaven, to give light upon the earth.

"And to rule over the day and over the night, and to divide the light from the darkness: and God saw that it was good.

"And the evening and the morning were the fourth day."

Genesis i: 14-19.

Symbol, cloud in Creator's star; reference same as Plate III.

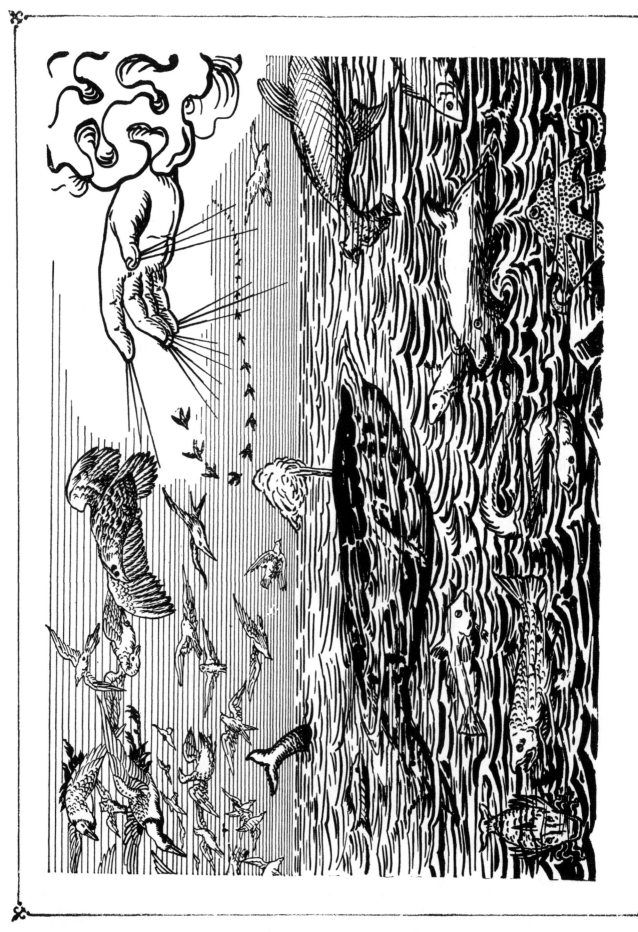

Plate *VII* SYMBOLS AND EMBLEMS

Fifth Day of Creation

"And God said, Let the waters bring forth abundantly the moving creature that hath life, and fowl that may fly above the earth in the open firmament of heaven.

"And God created great whales, and every living creature that moveth, which the waters brought forth abundantly after their kind: and God saw that it was good.

"And God blessed them, saying, Be fruitful. and multiply, and fill the waters in the seas ; and let fowl multiply in the earth.

" And the evening and the morning were the fifth day."

Genesis i : 20-23.

The symbol used is the hand with rays.

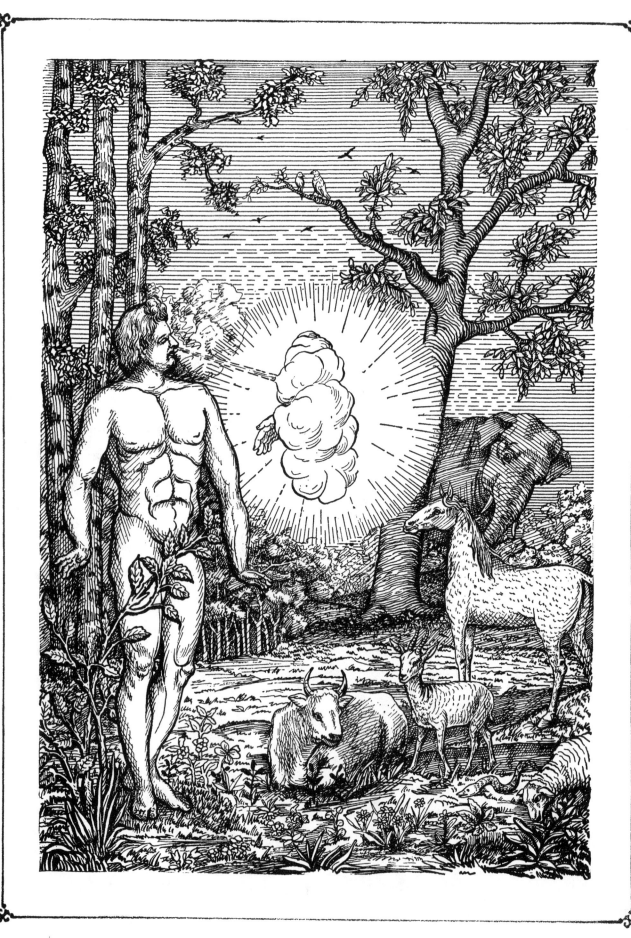

Plate *VIII* SYMBOLS AND EMBLEMS

Sixth Day of Creation

"And God said, Let the earth bring forth the living creature after his kind, cattle, and creeping thing, and beast of the earth after his kind: and it was so.

"And God made the beast of the earth after his kind, and cattle after their kind, and every thing that creepeth upon the earth after his kind: and God saw that it was good.

"And God said, Let us make man in our image, after our likeness; and let them have dominion over the fish of the sea, and over the fowl of the air, and over the cattle, and over all the earth, and over every creeping thing that creepeth upon the earth.

" So God created man in his own image, in the image of God created he him: male and female created he them.

"And God blessed them, and God said unto them, Be fruitful, and multiply, and replenish the earth, and subdue it; and have dominion over the fish of the sea, and over the fowl of the air, and over every living thing that moveth upon the earth.

"And God said, Behold I have given you every herb bearing seed, which is upon the face of all the earth, and every tree, in the which is the fruit of a tree yielding seed; to you it shall be for meat.

"And to every beast of the earth, and to every fowl of the air, and to every thing that creepeth upon the earth, wherein there is life, I have given every green herb for meat: and it was so.

"And God saw every thing that he had made, and, behold, it was very good. And the evening and the morning were the sixth day."

Genesis i: 24-31.

"And the Lord God formed man of the dust of the ground, and breathed into his nostrils the breath of life; and man became a living soul."

Genesis ii: 7.

" Thy hands have made me, and fashioned me."

Psalms cxix: 73.

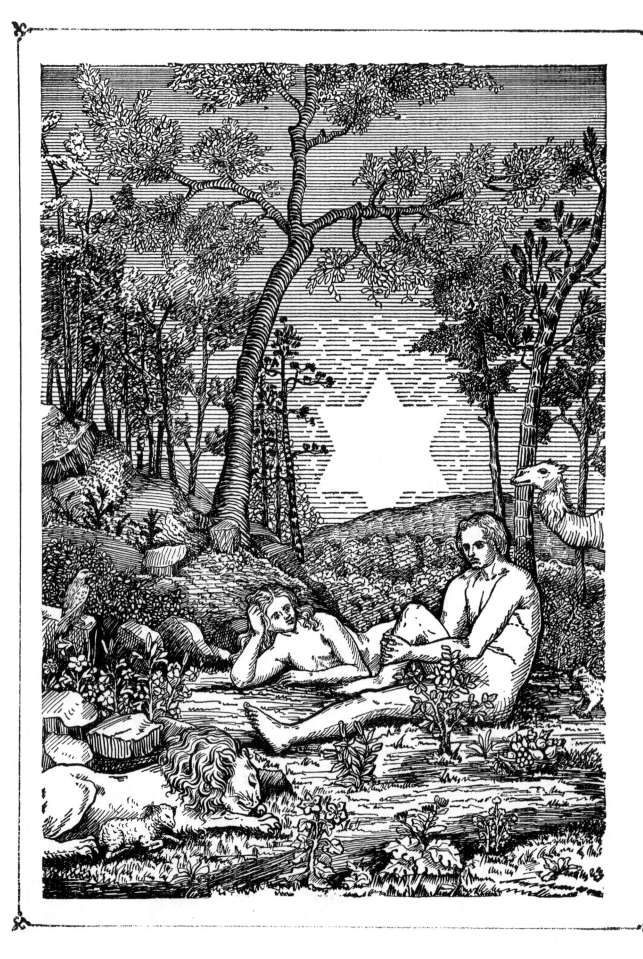

Plate IX SYMBOLS AND EMBLEMS

Seventh Day of Creation

" Thus the heavens and the earth were finished, and all the host of them.

"And on the seventh day God ended his work which he had made ; and he rested on the seventh day from all his work which he had made.

"And God blessed the seventh day, and sanctified it ; because that in it he had rested from all his work which God created and made."

Genesis ii : 1-3.

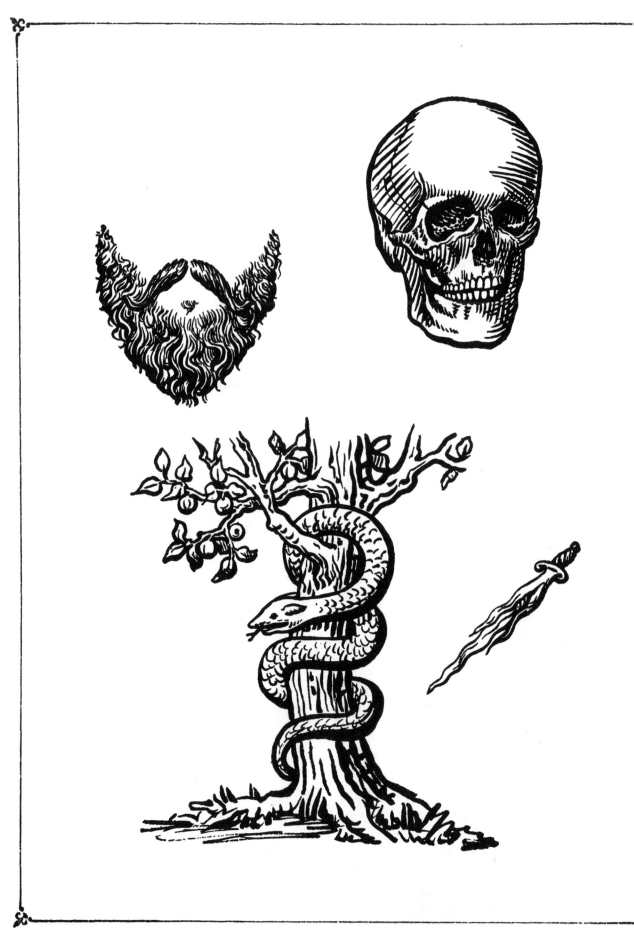

Plate X SYMBOLS AND EMBLEMS

(1)

Beard. Attribute. Emblematic of man (male.)

(2)

Skull. Symbol of mankind, or the human race.

(3)

Serpent. An emblem of sin. On the apple tree it is emblematic
of the temptation and fall.

> " And the serpent said unto the woman, Ye shall not surely die."
>
> *Genesis iii : 4.*

The apple tree is an emblem of the knowledge of good and evil.

(4)

The flaming sword suggests the expulsion from the Garden of Eden
and the punishment of Satan or sin.

> " So he drove out the man : and he placed at the east of the garden of Eden,
> cherubims, and a flaming sword which turned every way, to keep the way of the
> tree of life."
>
> *Genesis iii : 24.*

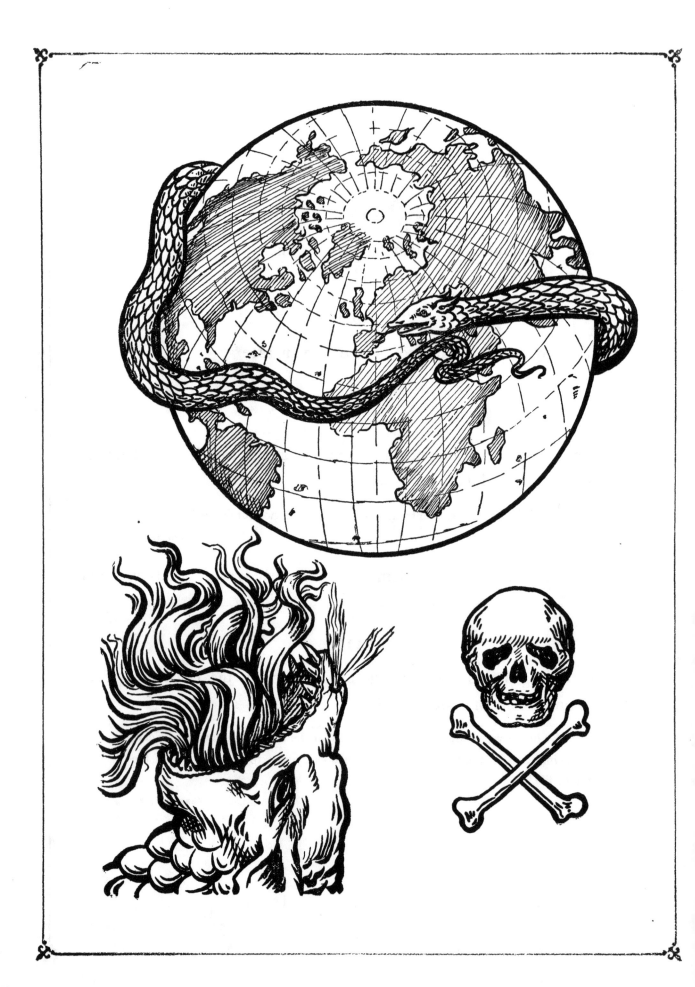

Plate XI SYMBOLS AND EMBLEMS

𝔚esults of the 𝔍all

(1)

The Snake (sin) encircling the world.

Through Adam's sin and fall, sin entered into, and had dominion over, the whole world.

See Romans v : 12 ; 1st John v : 19.

(2)

The Jaws of Hell.

"Therefore hell hath enlarged herself, and opened her mouth without measure."

Isaiah v : 14.

(3)

Skull and Crossbones.

This is a very old, and much used, emblem of Death.

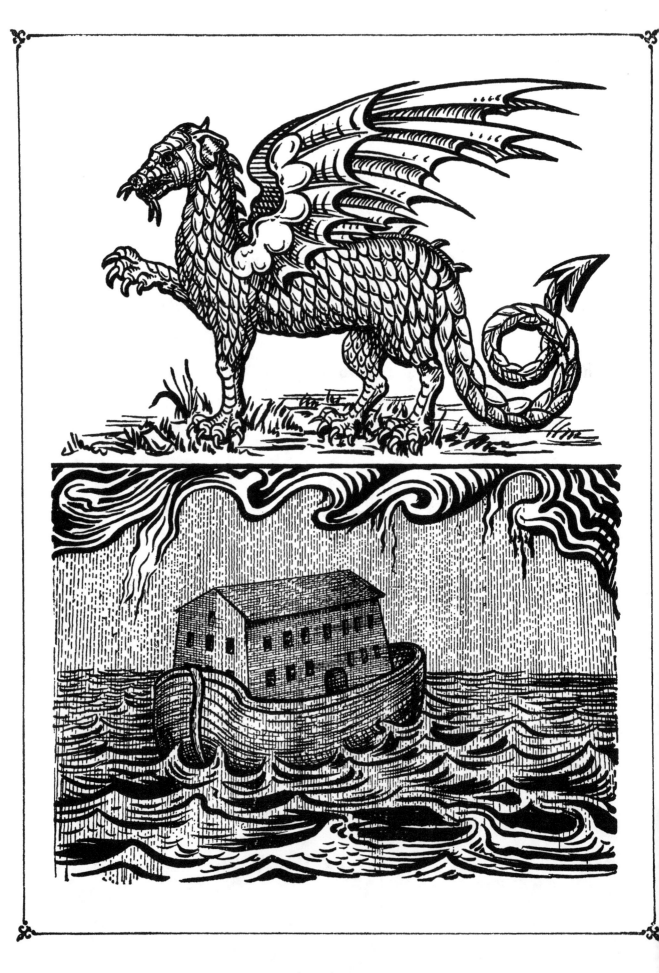

Plate XII SYMBOLS AND EMBLEMS

(1)

Dragon. The Dragon is an emblem of Satan or sin. It is also used as an emblem of pestilence. *See Rev. xii: 9.*

✠

Results of the Dominion of Sin

" And God saw that the wickedness of man was great in the earth, and that every imagination of the thoughts of his heart was only evil continually.

"And it repented the Lord that he had made man on the earth, and it grieved him at his heart.

" And the Lord said, I will destroy man, whom I have created, from the face of the earth; both man and beast, and the creeping thing, and the fowls of the air : for it repenteth me that I have made them."

Genesis vi: 5-7.

(2)

The Flood.

" And the flood was forty days upon the earth ; and the waters increased, and bare up the ark, and it was lift up above the earth.

" And the waters prevailed, and were increased greatly upon the earth ; and the ark went upon the face of the waters.

" And the waters prevailed exceedingly upon the earth ; and all the high hills, that were under the whole heaven, were covered.

" Fifteen cubits upward did the waters prevail; and the mountains were covered.

"And all flesh died that moved upon the earth, both of fowl, and of cattle, and of beast, and of every creeping thing that creepeth upon the earth, and every man.

"All in whose nostrils was the breath of life, of all that was in the dry land, died.

" And every living substance was destroyed which was upon the face of the ground, both man, and cattle, and the creeping things, and the fowl of the heaven; and they were destroyed from the earth: and Noah only remained alive, and they that were with him in the ark.

"And the waters prevailed upon the earth an hundred and fifty days."

Genesis vii: 17-24.

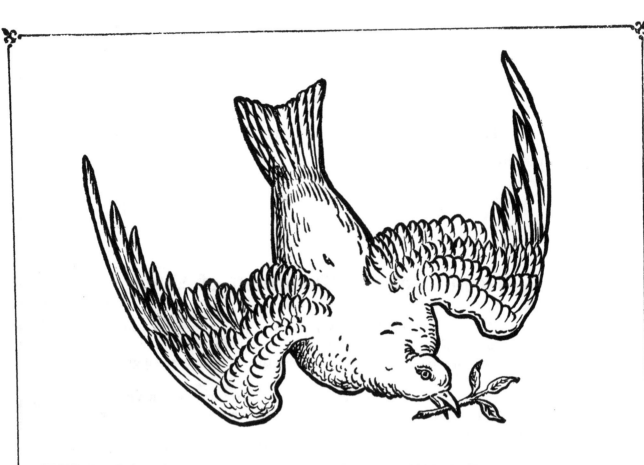

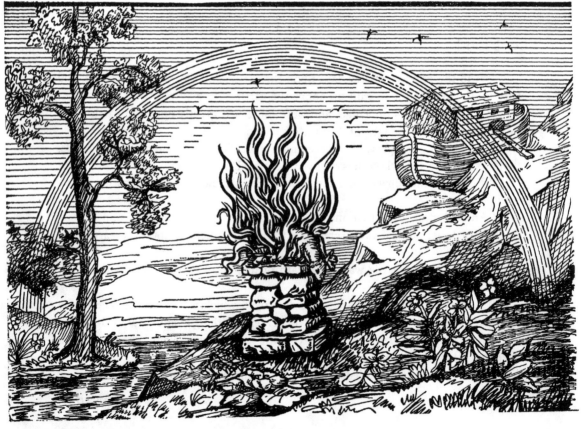

Plate XIII SYMBOLS AND EMBLEMS

(1)

Returning Dove

Emblematic of peace and returning prosperity.

> "And the dove came into him in the evening : and lo, in her mouth was an olive leaf pluckt off : so Noah knew that the waters were abated from off the earth."
>
> *Gen. viii : 11.*

✠

(2)

Thanksgiving and Promise

> "And Noah builded an altar unto the Lord : and took every clean beast, and every clean fowl, and offered burnt offerings on the altar."
>
> *Gen. viii : 20.*

> "And God said, This is the token of the covenant which I make between me and you and every living creature that is with you, for perpetual generations :
>
> "I do set my bow in the cloud, and it shall be for a token of a covenant between me and the earth.
>
> "And it shall come to pass, when I bring a cloud over the earth, that the bow shall be seen in the cloud :
>
> "And I will remember my covenant, which is between me and you and every living creature of all flesh : and the waters shall no more become a flood to destroy all flesh.
>
> "And the bow shall be set in the cloud : and I will look upon it, that I may remember the everlasting covenant between God and every living creature of the earth.
>
> "And God said unto Noah, This is the token of the covenant, which I have established between me and all flesh that is upon the earth."
>
> *Gen. ix : 12-17.*

The rainbow is symbolic of God's mercy and faithfulness.

Plate XIV SYMBOLS AND EMBLEMS

(1)

The Burning Bush.

> "And the angel of the Lord appeared unto him in a flame of fire, out of the midst of a bush : and he looked, and, behold, the bush burned with fire, and the bush was not consumed."
>
> *Exodus iii : 2.*

The bush is generally said to have been an acacia tree.

(2)

Jehovah's promise to Abram.

> "And he brought him forth abroad, and said, Look now toward heaven, and tell the stars, if thou be able to number them. And he said unto him, So shall thy seed be."
>
> *Genesis xv : 5. (See also Acts iii : 25.)*

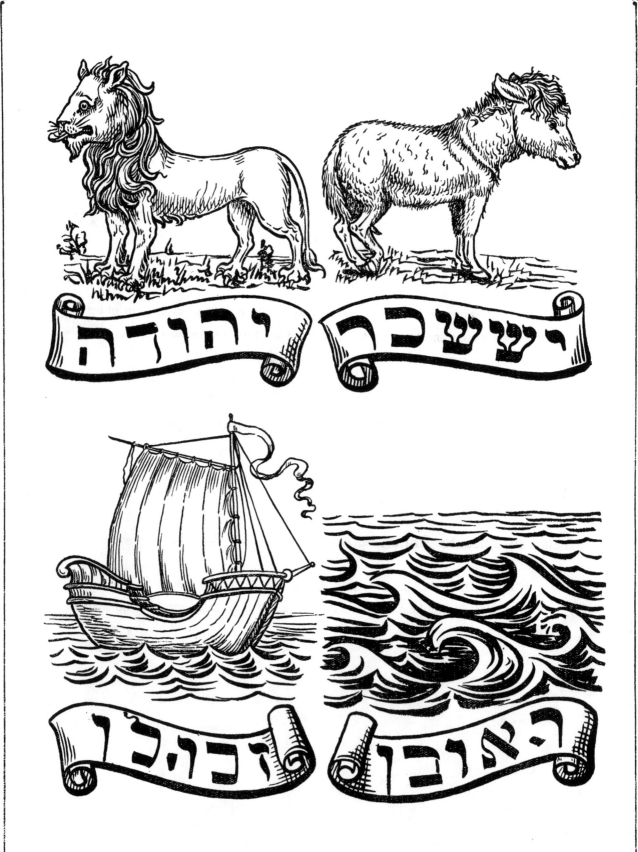

Plate XV SYMBOLS AND EMBLEMS

Emblems of the Twelve Tribes

" And Jacob called unto his sons, and said, Gather yourselves together, that I may tell you that which shall befall you in the last days.

" Gather yourselves together, and hear, ye sons of Jacob ; and hearken unto Israel your father."

Genesis xlix : 1, 2.

Judah ; emblem, a Lion.

" Judah, thou art he whom thy brethren shall praise ; thy hand shall be in the neck of thine enemies : thy father's children shall bow down before thee.

" Judah is a lion's whelp ; from the prey, my son, thou art gone up : he stooped down, he couched as a lion, and as an old lion ; who shall rouse him up?

" The sceptre shall not depart from Judah, nor a lawgiver from between his feet, until Shiloh come ; and unto him shall the gathering of the people be.

" Binding his foal unto the vine, and his ass's colt unto the choice vine ; he washed his garments in wine, and his clothes in the blood of grapes :

" His eyes shall be red with wine, and his teeth white with milk."

Genesis xlix : 8-12.

Issachar ; emblem, an Ass.

" Issachar is a strong ass, couching down between two burdens :

"And he saw that rest was good, and the land that it was pleasant ; and bowed his shoulder to bear, and became a servant unto tribute."

Genesis xlix : 14, 15.

Zebulun ; emblem, a Ship.

" Zebulun shall dwell at the haven of the sea ; and he shall be for an haven of ships : and his border shall be unto Zidon."

Genesis xlix : 13.

Reuben ; emblem, the Sea.

" Reuben, thou art my first-born, my might, and the beginning of my strength, the excellency of dignity, and the excellency of power.

"Unstable as water, thou shalt not excel ; because thou wentest up to thy father's bed ; then defiledst thou it ; he went up to my couch."

Genesis xlix : 3, 4.

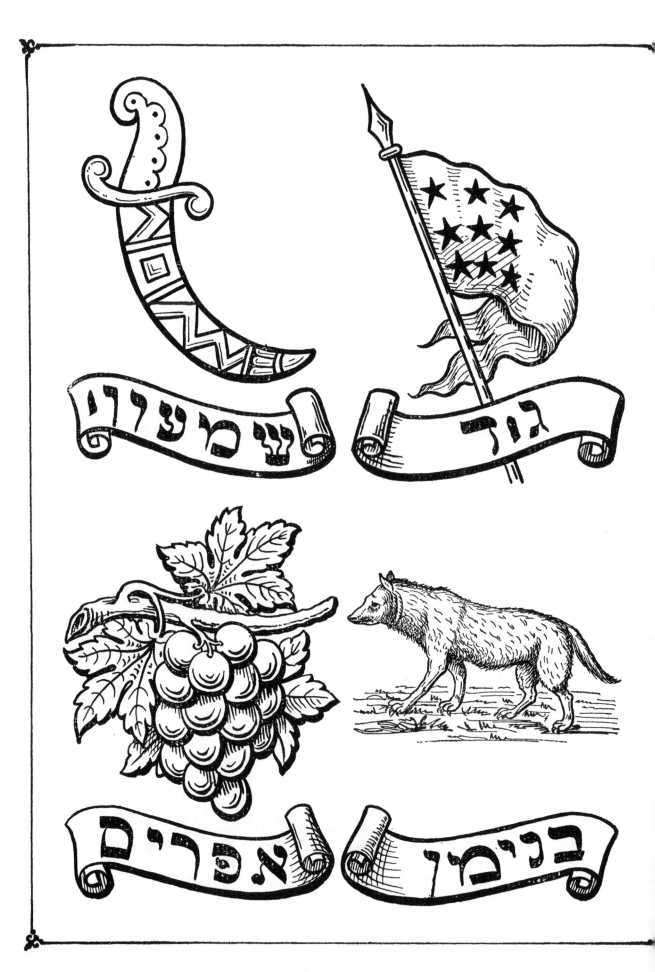

שמעון

גד

בנימן

אפרים

Plate XVI SYMBOLS AND EMBLEMS

Simeon; emblem, a Sword.

" Simeon and Levi are brethren; instruments of cruelty are in their habitations.

" O, my soul, come not thou into their secret ; unto their assembly, mine honour, be not thou united: for in their anger they slew a man, and in their self-will they digged down a wall.

" Cursed be their anger, for it was fierce; and their wrath, for it was cruel: I will divide them in Jacob, and scatter them in Israel."

Genesis xlix : 5-7.

Gad ; emblem, a Standard.

" Gad, a troop shall overcome him ; but he shall overcome at the last."

Genesis xlix : 19.

Ephraim ; emblem, a Vine.

"And when Joseph saw that his father laid his right hand upon the head of Ephraim, it displeased him ; and he held up his father's hand, to remove it from Ephraim's head unto Manasseh's head.

" And Joseph said unto his father, Not so, my father: for this is the firstborn ; put thy right hand upon his head.

" And his father refused, and said, I know it, my son, I know it: he also shall become a people, and he also shall be great; but truly his younger brother shall be greater than he, and his seed shall become a multitude of nations.

"And he blessed them that day, saying, In thee shall Israel bless, saying, God make thee as Ephraim, and as Manasseh : and he set Ephraim before Manasseh.

"And Israel said unto Joseph, Behold, I die; but God shall be with you, and bring you again unto the land of your fathers.

" Moreover, I have given to thee one portion above thy brethren, which I took out of the hand of the Amorite with my sword and with my bow."

Genesis xlviii : 17-22.

Benjamin ; emblem, a Wolf.

" Benjamin shall ravin as a wolf; in the morning he shall devour the prey, and at night he shall divide the spoil."

Genesis xlix : 27.

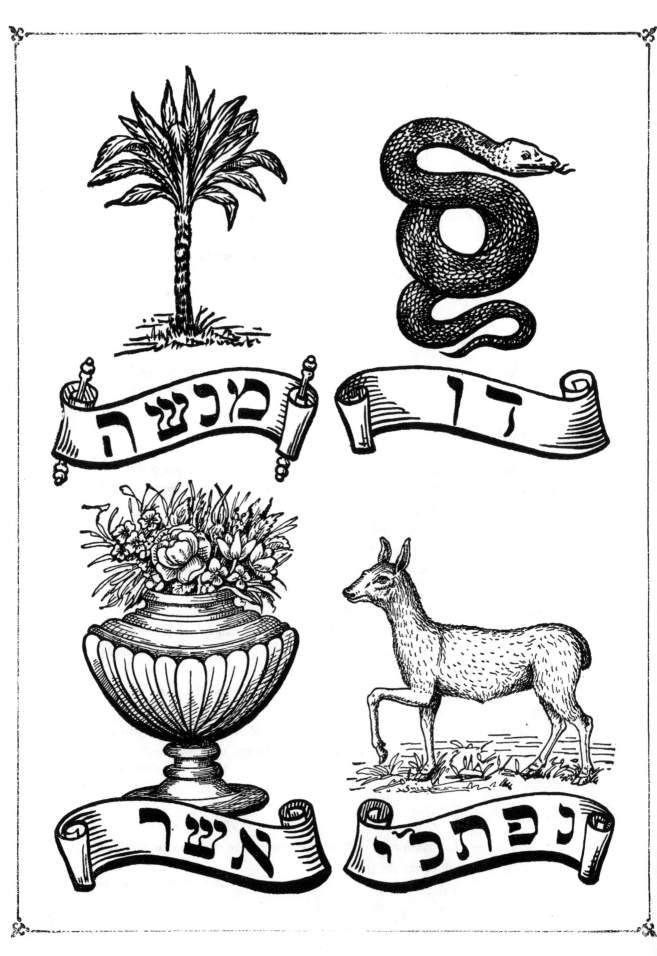

Plate XVII SYMBOLS AND EMBLEMS

Manasseh; emblem, a Palm. (Reference the same as for Ephraim.)

Dan; emblem, a Serpent.

"Dan shall judge his people, as one of the tribes of Israel.

"Dan shall be a serpent by the way, an adder in the path, that biteth the horse heels, so that his rider shall fall backward.

"I have waited for thy salvation, O Lord."

Genesis xlix : 16-18.

Asher; emblem, a Vase.

"Out of Asher his bread shall be fat, and he shall yield royal dainties."

Genesis xlix : 20.

Naphtali; emblem, a Hind.

"Naphtali is a hind let loose; he giveth goodly words."

Genesis xlix : 21.

In the division of the promised land the Levites received no portion, but were to receive one-tenth of the products from the other tribes; they in turn were to give one-tenth to the Priests.

The Ten Commandments

"And God spake all these words, saying,

"I am the Lord thy God, which have brought thee out of the land of Egypt, out of the house of bondage.

"Thou shalt have no other gods before me.

"Thou shalt not make unto thee any graven image, or any likeness of any thing that is in heaven above, or that is in the earth beneath, or that is in the water under the earth:

"Thou shalt not bow down thyself to them, nor serve them: for I the Lord thy God am a jealous God, visiting the iniquity of the fathers upon the children unto the third and fourth generation of them that hate me;

"And showing mercy unto thousands of them that love me, and keep my commandments.

"Thou shalt not take the name of the Lord thy God in vain; for the Lord will not hold him guiltless that taketh his name in vain.

"Remember the sabbath day to keep it holy.

"Six days shalt thou labour, and do all thy work:

"But the seventh day is the sabbath of the Lord thy God: in it thou shalt not do any work, thou, nor thy son, nor thy daughter, thy man-servant, nor thy maid-servant, nor thy cattle, nor thy stranger that is within thy gates:

"For in six days the Lord made heaven and earth, the sea, and all that in them is, and rested the seventh day: wherefore the Lord blessed the sabbath day, and hallowed it.

"Honour thy father and thy mother; that thy days may be long upon the land which the Lord thy God giveth thee.

"Thou shalt not kill.

"Thou shalt not commit adultery.

"Thou shalt not steal.

"Thou shalt not bear false witness against thy neighbour.

"Thou shalt not covet thy neighbour's house, thou shalt not covet thy neighbour's wife, nor his man-servant, nor his maid-servant, nor his ox, nor his ass, nor any thing that is thy neighbour's."

Exodus xx: 1-17.

"And he gave unto Moses, when he had made an end of communing with him upon mount Sinai, two tables of testimony, tables of stone, written with the finger of God."

Exodus xxxi: 18.

Represents the Pentateuch or Torah, the name given to the first five books of the Bible.

The Pentateuch is always written by hand, and on vellum. Being hand work, it is expensive,—sometimes exceedingly so.

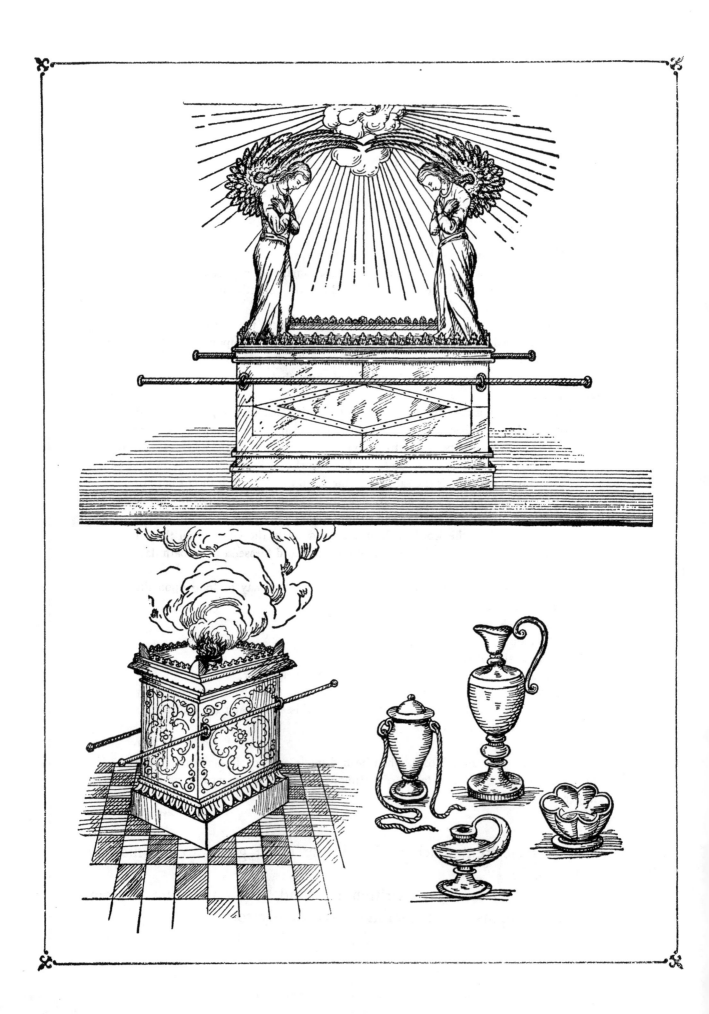

Plate XIX SYMBOLS AND EMBLEMS

(I)

Ark of the Covenant.

" And they shall make an ark of shittim-wood: two cubits and a half shall be the length thereof, and a cubit and a half the breadth thereof, and a cubit and a half the height thereof.

"And thou shalt overlay it with pure gold; within and without shalt thou overlay it, and shalt make upon it a crown of gold round about.

"And thou shalt cast four rings of gold for it, and put them in the four corners thereof; and two rings shall be in the one side of it, and two rings in the other side of it.

" And thou shalt make staves of shittim-wood, and overlay them with gold.

"And thou shalt put the staves into the rings by the sides of the ark, that the ark may be borne with them.

" The staves shall be in the rings of the ark ; they shall not be taken from it.

"And thou shalt put into the ark the testimony which I shall give thee.

"And thou shalt make a mercy-seat of pure gold: two cubits and a half shall be the length thereof, and a cubit and a half the breadth thereof.

"And thou shalt make two cherubims of gold, of beaten work shalt thou make them, in the two ends of the mercy-seat.

"And make one cherub on the one end, and the other cherub on the other end; even of the mercy-seat shall ye make the cherubims on the two ends thereof.

" And the cherubims shall stretch forth their wings on high, covering the mercy-seat with their wings, and their faces shall look one to another; toward the mercy-seat shall the faces of the cherubims be.

"And thou shalt put the mercy-seat above upon the ark; and in the ark thou shalt put the testimony that I shall give thee.

"And there I will meet with thee, and I will commune with thee from above the mercy-seat, from between the two cherubims which are upon the ark of the testimony, of all things which I will give thee in commandment unto the children of Israel."

Exodus xxv : 10-22.

The Christians use the Ark of the Covenant, the Cherubims, the Mercy Seat, and the Divine Shechinah, as symbolical of Christ, the divine presence and the promised place of meeting.

(2)

Altar of Incense.

"And thou shalt make an altar to burn incense upon: of shittim-wood shalt thou make it.

"A cubit shall be the length thereof, and a cubit the breadth thereof; four-square shall it be: and two cubits shall be the height thereof: the horns thereof shall be of the same.

"And thou shalt overlay it with pure gold, the top thereof, and the sides thereof round about, and the horns thereof: and thou shalt make unto it a crown of gold round about.

"And two golden rings shalt thou make to it under the crown of it, by the two corners thereof; upon the two sides of it shalt thou make it; and they shall be for places for the staves to bear it withal.

"And thou shalt make the staves of shittim-wood, and overlay them with gold.

"And thou shalt put it before the vail that is by the ark of the testimony, before the mercy-seat that is over the testimony, where I will meet with thee.

"And Aaron shall burn thereon sweet incense every morning: when he dresseth the lamps, he shall burn incense upon it.

"And when Aaron lighteth the lamps at even, he shall burn incense upon it: a perpetual incense before the Lord throughout your generations.

" Ye shall offer no strange incense thereon, nor burnt-sacrifice, nor meat-offering ; neither shall ye pour drink-offering thereon.

"And Aaron shall make an atonement upon the horns of it once in a year with the blood of the sin-offering of atonements: once in the year shall he make atonement upon it, throughout your generations: it is most holy unto the Lord."

Exodus xxx: 1-10.

Altar of Incense, with the perpetual fire burning, typifies the perpetual intercession of Christ.

(3)

Vessels used in the Tabernacle.

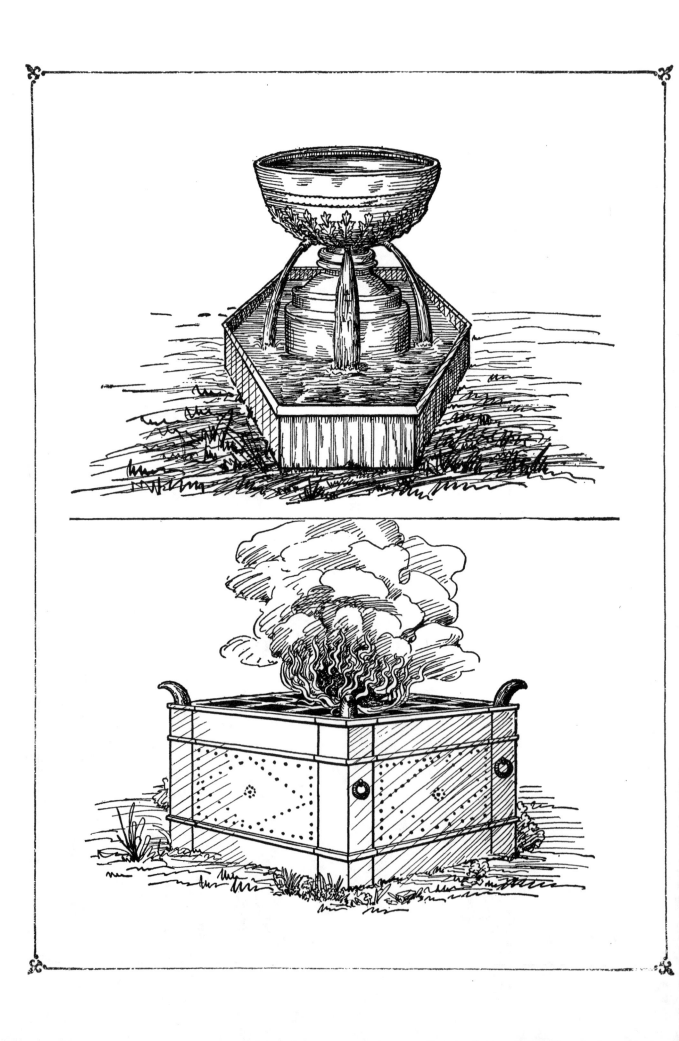

Plate XX SYMBOLS AND EMBLEMS

(I)

Brazen Laver.

" Thou shalt also make a laver of brass, and his foot also of brass, to wash withal : and thou shalt put it between the tabernacle of the congregation and the altar, and thou shalt put water therein :

" For Aaron and his sons shall wash their hands and their feet thereat.

" When they go into the tabernacle of the congregation, they shall wash with water, that they die not; or when they come near to the altar to minister, to burn offering made by fire unto the Lord :

" So they shall wash their hands and their feet, that they die not; and it shall be a statute for ever to them, even to him and to his seed throughout their generations."

Exodus xxx : 18-21.

Laver filled with water; emblematic of the Holy Spirit and of the freedom oi purification.

See John vii : 37-39 ; Eph. v : 26.

(2)

Altar of Burnt Offering.

"And thou shalt make an altar of shittim-wood, five cubits long, and five cubits broad ; the altar shall be four-square ; and the height thereof shall be three cubits.

"And thou shalt make the horns of it upon the four corners thereof: his horns shall be of the same : and thou shalt overlay it with brass.

"And thou shalt make his pans to receive his ashes, and his shovels, and his basons, and his flesh-hooks, and his fire-pans : all the vessels thereof thou shalt make of brass.

"And thou shalt make for it a grate of net-work of brass ; and upon the net shalt thou make four brazen rings in the four corners thereof.

"And thou shalt put it under the compass of the altar beneath, that the net may be even to the midst of the altar.

"And thou shalt make staves for the altar, staves of shittim-wood, and overlay them with brass.

"And the staves shall be put into the rings, and the staves shall be upon the two sides of the altar, to bear it.

" Hollow with boards shalt thou make it ; as it was shewed thee in the mount so shall they make it."

Exodus xxvii : 1-8.

Altar of Burnt Offering; typical of Christ and His cross, where all was given to God.

See Hebrews x : 10.

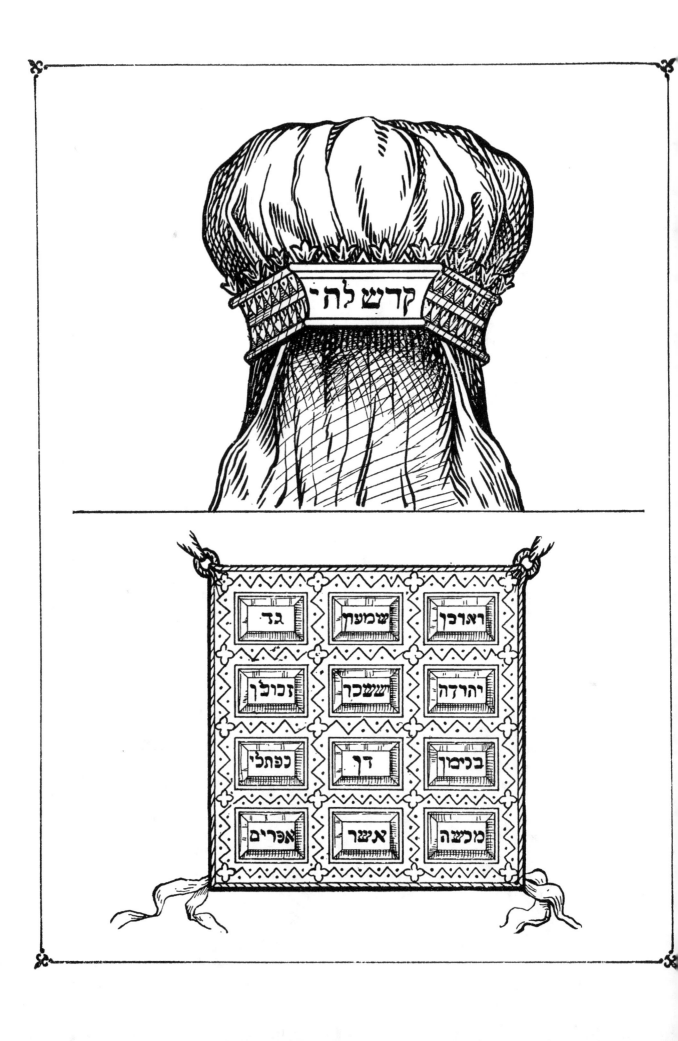

Plate XXI SYMBOLS AND EMBLEMS

(1)

Mitre.

"And thou shalt make a plate of pure gold, and grave upon it, like the engravings of a signet, HOLINESS TO THE LORD.

" And thou shalt put it on a blue lace, that it may be upon the mitre; upon the fore front of the mitre it shall be.

"And it shall be upon Aaron's forehead, that Aaron may bear the iniquity of the holy things, which the children of Israel shall hallow in all their holy gifts; and it shall be always upon his forehead, that they may be accepted before the Lord."

Exodus xxviii: 36-38.

(2)

Breastplate.

"And thou shalt make the breastplate of judgment with cunning work; after the work of the ephod thou shalt make it; of gold, of blue, and of purple, and of scarlet, and of fine twined linen, shalt thou make it.

" Four-square it shall be, being doubled; a span shall be the length thereof, and a span shall be the breadth thereof.

"And thou shalt set in it settings of stones, even four rows of stones: the first row shall be a sardius, a topaz, and a carbuncle: this shall be the first row.

"And the second row shall be an emerald, a sapphire, and a diamond.

"And the third row a ligure, an agate, and an amethyst.

" And the fourth row a beryl, and an onyx, and a jasper: they shall be set in gold in their inclosings.

"And the stones shall be with the names of the children of Israel, twelve, according to their names, like the engravings of a signet; every one with his name shall they be according to the twelve tribes.

Breastplate.—*Continued.*

"And thou shalt make upon the breastplate chains at the ends of wreathen work of pure gold.

"And thou shalt make upon the breastplate two rings of gold, and shalt put the two rings on the two ends of the breastplate.

"And thou shalt put the two wreathen chains of gold in the two rings which are on the ends of the breastplate.

"And the other two ends of the two wreathen chains thou shalt fasten in the two ouches, and put them on the shoulderpieces of the ephod before it.

"And thou shalt make two rings of gold, and thou shalt put them upon the two ends of the breastplate, in the border thereof, which is in the side of the ephod inward.

"And two other rings of gold thou shalt make, and shalt put them on the two sides of the ephod underneath, toward the forepart thereof, over against the other coupling thereof, above the curious girdle of the ephod.

" And they shall bind the breastplate by the rings thereof unto the rings of the ephod with a lace of blue, that it may be above the curious girdle of the ephod, and that the breastplate be not loosed from the ephod.

" And Aaron shall bear the names of the children of Israel in the breastplate of judgment upon his heart, when he goeth in unto the holy place, for a memorial before the Lord continually.

"And thou shalt put in the breastplate of judgment the Urim and the Thummim; and they shall be upon Aaron's heart, when he goeth in before the Lord: and Aaron shall bear the judgment of the children of Israel upon his heart before the Lord continually."

Exodus xxviii : 15-30.

Urim means light and Thummim perfection. Supposed to have been precious stones.

Josephus supposed that the stones gave out oracular answer by preternatural illumination, but we have no positive knowledge what they were.

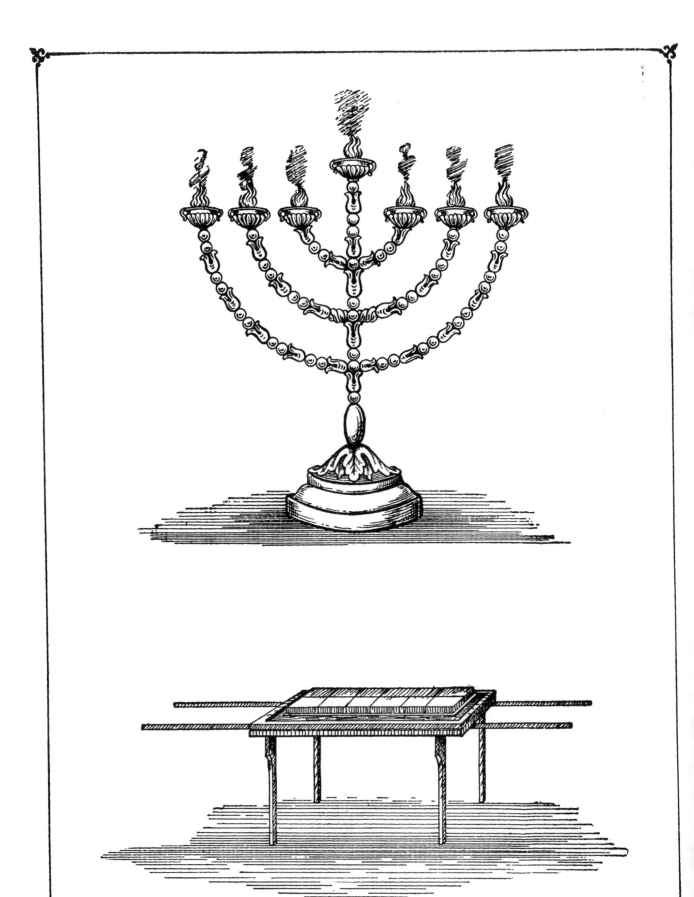

Plate XXII　　　　　　　　　　　　SYMBOLS AND EMBLEMS

(I)

Candlestick.

"And thou shalt make a candlestick of pure gold; of beaten work shall the candlestick be made: his shaft, and his branches, his bowls, his knops, and his flowers, shall be of the same.

"And six branches shall come out of the sides of it: three branches of the candlestick out of the one side, and three branches of the candlestick out of the other side:

"Three bowls made like unto almonds, with a knop and a flower in one branch; and three bowls made like almonds in the other branch, with a knop and a flower; so in the six branches that come out of the candlestick.

"And in the candlestick shall be four bowls made like unto almonds, with their knops and their flowers.

"And there shall be a knop under two branches of the same, and a knop under two branches of the same, and a knop under two branches of the same, according to the six branches that proceed out of the candlestick.

"Their knops and their branches shall be of the same: all of it shall be one beaten work of pure gold.

"And thou shalt make the seven lamps thereof; and they shall light the lamps thereof, that they may give light over against it.

"And the tongs thereof, and the snuff-dishes thereof, shall be of pure gold.

"Of a talent of pure gold shall he make it, with all these vessels.

"And look that thou make them after their pattern, which was showed thee in the mount."

Exodus xxv : 31-40.

Candlestick; emblematic of Christ and the Church, as the light of the world.

See John viii : 12.

(2)

Table of Shewbread.

"Thou shalt also make a table of shittim-wood: two cubits shall be the length thereof, and a cubit the breadth thereof, and a cubit and a half the height thereof.

"And thou shalt overlay it with pure gold, and make thereto a crown of gold round about.

"And thou shalt make unto it a border of an hand-breadth round about, and thou shalt make a golden crown to the border thereof round about.

"And thou shalt make for it four rings of gold, and put the rings in the four corners that are on the four feet thereof.

"Over against the border shall the rings be for places of the staves to bear the table.

"And thou shalt make the staves of shittim-wood, and overlay them with gold, that the table may be borne with them.

"And thou shalt make the dishes thereof, and spoons thereof, and covers thereof, and bowls thereof, to cover withal; of pure gold shalt thou make them.

"And thou shalt set upon the table shewbread before me alway."

Exodus xxv : 23-30.

Table of shewbread; a symbol of the body of Christ, lifted up, incorruptible.

See John vi : 48-51.

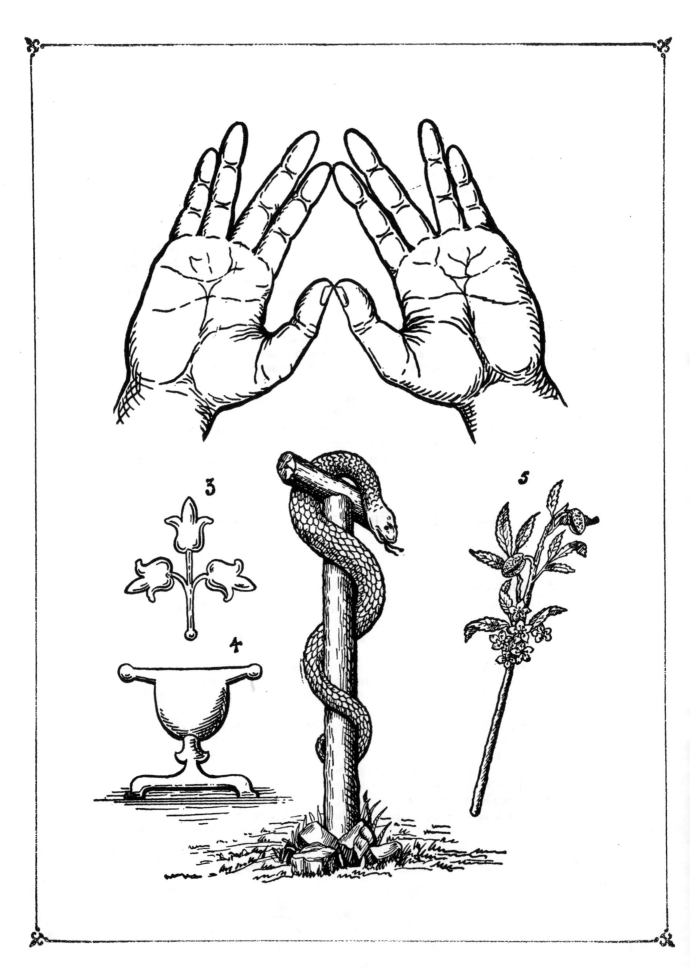

Plate *XXIII* SYMBOLS AND EMBLEMS

(1)

Form of Benediction.

Sometimes the index fingers do not touch each other, and instead of the tips of thumbs touching, the first joints are placed together. Either way forms four openings, each opening representing one of the four Hebrew letters that form the word Jehovah.

(2)

The Brazen Serpent.

" And the Lord said unto Moses, Make thee a fiery serpent, and set it upon a pole : and it shall come to pass, that every one that is bitten, when he looketh upon it, shall live.

"And Moses made a serpent of brass, and put it upon a pole : and it came to pass, that if a serpent had bitten any man, when he beheld the serpent of brass, he lived."

Numbers xxi : 8, 9.

Typical of the Crucifixion.

See John iii : 14.

(3)

A conventional and well-known form of Aaron's Rod.

(4)

A conventional form of the Manna Pot.

See Ex. xvi : 4-36.

(5)

A natural representation of Aaron's Rod.

"And it came to pass, that on the morrow, Moses went into the tabernacle of witness ; and, behold, the rod of Aaron for the house of Levi was budded, and brought forth buds, and bloomed blossoms, and yielded almonds."

Numbers xvii : 8.

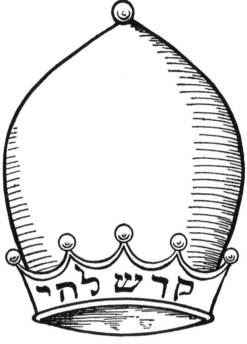
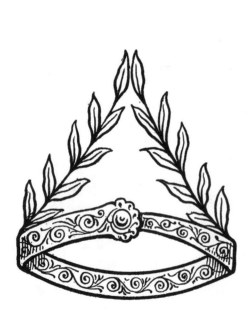

Plate XXIV SYMBOLS AND EMBLEMS

Crowns and Wreaths

The crown is the symbol of sovereignty and superiority.

(1)

Crown of the King.

(2)

Crown of the Priest, for marked or eminent holiness.

(3)

Crown of the Scholar, for excellent learning.

(4)

Wreaths. There were three wreaths in the Sanctuary:

Wreath of the Ark.

Wreath of the Table.

Wreath of the Altar.

The wreath of the altar was won by Aaron for priestly merit. The wreath of the table was won by David for material prosperity. But the wreath of the ark (duty) might be earned by all who strove for it.

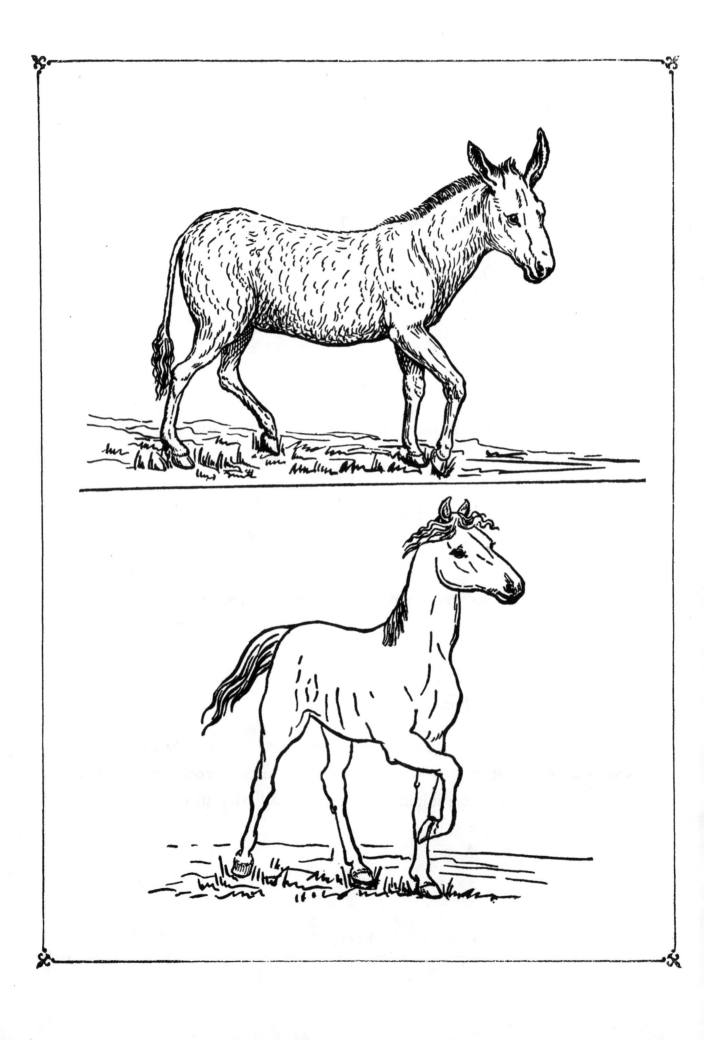

Plate XXV SYMBOLS AND EMBLEMS

(I)

Ass ; emblem of peace and sovereignty.

The ass was an honored animal, and was used by kings, prophets and nobles.

"Speak, ye that ride on white asses, ye that sit in judgment."

Judges v: 10.

(2)

Horse ; emblem of turmoil and war.

" Hast thou given the horse strength? hast thou clothed his neck with thunder?

" Canst thou make him afraid as a grasshopper? the glory of his nostrils is terrible.

" He paweth in the valley, and rejoiceth in his strength ; he goeth on to meet the armed men.

" He mocketh at fear, and is not affrighted ; neither turneth he back from the sword.

" The quiver rattleth against him, the glittering spear and the shield.

" He swalloweth the ground with fierceness and rage ; neither believeth he that it is the sound of the trumpet.

" He saith among the trumpets, Ha, ha ; and he smelleth the battle afar off, the thunder of the captains, and the shouting."

Job xxxix : 19-25.

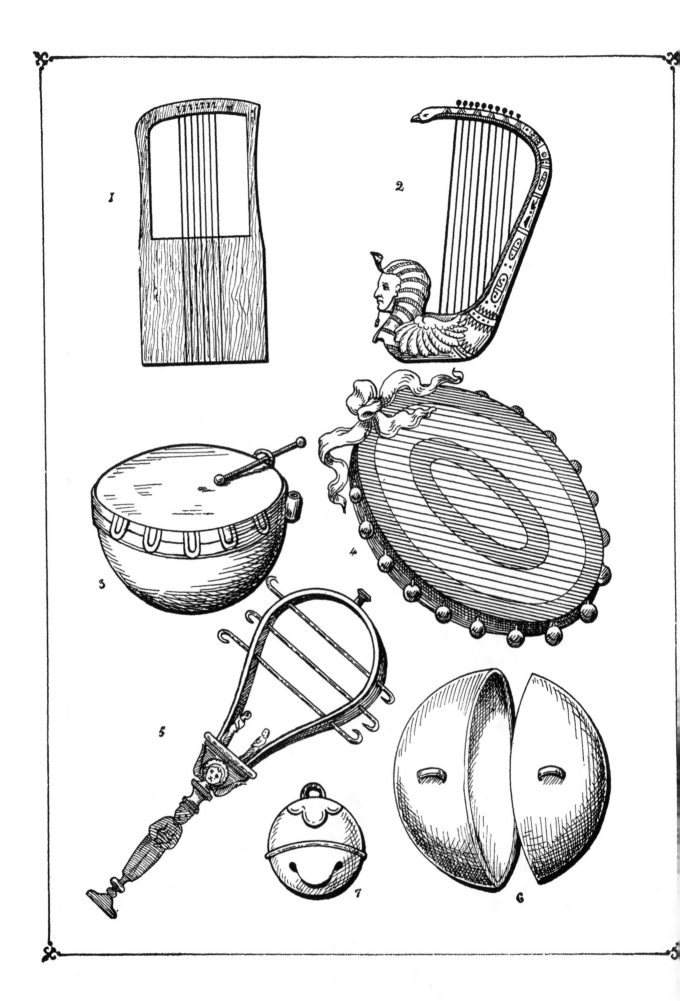

Plate XXVI SYMBOLS AND EMBLEMS

Musical Instruments of the Hebrews

Musical instruments mentioned in the Bible ; frequently used in church decoration.

(1)

Supposed ancient Hebrew Lyre.

(2)

Egyptian Harp, of same period.

(3)

Hebrew Drum.

> " The women came out of all the cities of Israel, singing and dancing, to meet king Saul, with tabrets, with joy, and with instruments of music."
>
> *1 Sam. xviii : 6.*

(4)

Timbrel.

> " And Miriam the prophetess, the sister of Aaron, took a timbrel in her hand ; and all the women went out after her with timbrels and with dances."
>
> *Ex. xv : 20.*

(5)

Systra or Cymbal.

(6)

Cymbals.

> " Thus all Israel brought up the ark of the covenant of the Lord with shouting, and with sound of the cornet, and with trumpets, and with cymbals, making a noise with psalteries and harps."
>
> *1 Chron. xv : 28.*

(7)

Bells.

> "A golden bell and a pomegranate, a golden bell and a pomegranate upon the hem of the robe round about.
>
> "And it shall be upon Aaron to minister ; and his sound shall be heard when he goeth in unto the holy place before the Lord, and when he cometh out, that he die not."
>
> *Ex. xxviii : 34, 35.*

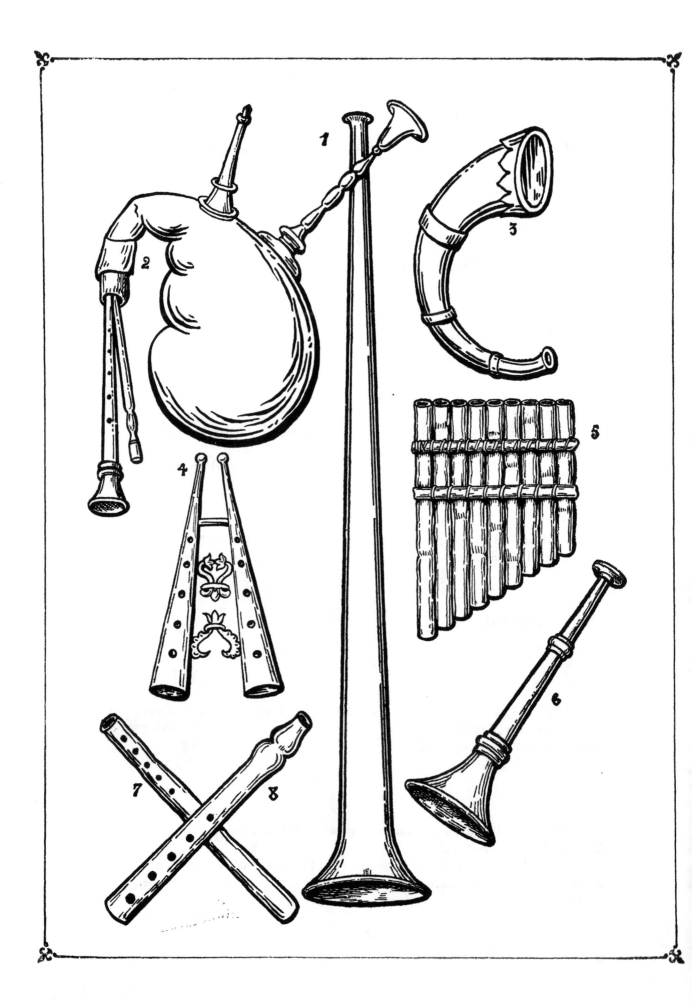

Plate *XXVII* SYMBOLS AND EMBLEMS

Musical Instruments

(Continued.)

(1)

Trumpet (shophar).

This is a very long horn, which is turned up at the extremity. This trumpet was used for rousing the people to political or religious enthusiasm. It was probably blown only by those who were divinely commissioned and was the token that God was on their side.

See Chron. xv: 28; Ex. xix: 16; Josh. vi: 4.

(2)

Ancient Dulcimer. A kind of bag-pipe.

See Dan. iii: 5.

(3)

Horn.

The original horns were cattle horns, but later they were made of metal, in the shapes of horns of various animals.

(4)

Flageolet. An ancient flute.

Sometimes the two pipes were connected with one mouth-piece.

(5)

Organ (ugab). A set of pipes, or reeds, and blown with the mouth. Sometimes there were from five to twenty-three pipes, but usually there were only seven.

(6)

A straight Trumpet.

(7 and 8)

Flute. No. 7 is a reed flute; No. 8 is a flute of later date.

A pipe originally made from reeds, perforated with holes; afterwards it was made of ivory, bone, or horn. It was consecrated to joy or pleasure.

NOTE.—Besides most of the foregoing, there may be used in decorating Jewish temples many of the following illustrations: such as the wheat sheaf, cornucopia, olive, palm, myrrh, wormwood, almond, lily of the valley, balm of Gilead, fig, frankincense, hyssop, cut flowers, scythe, hour glass, all-seeing eye, lamp; or any that have an Old Testament reference.

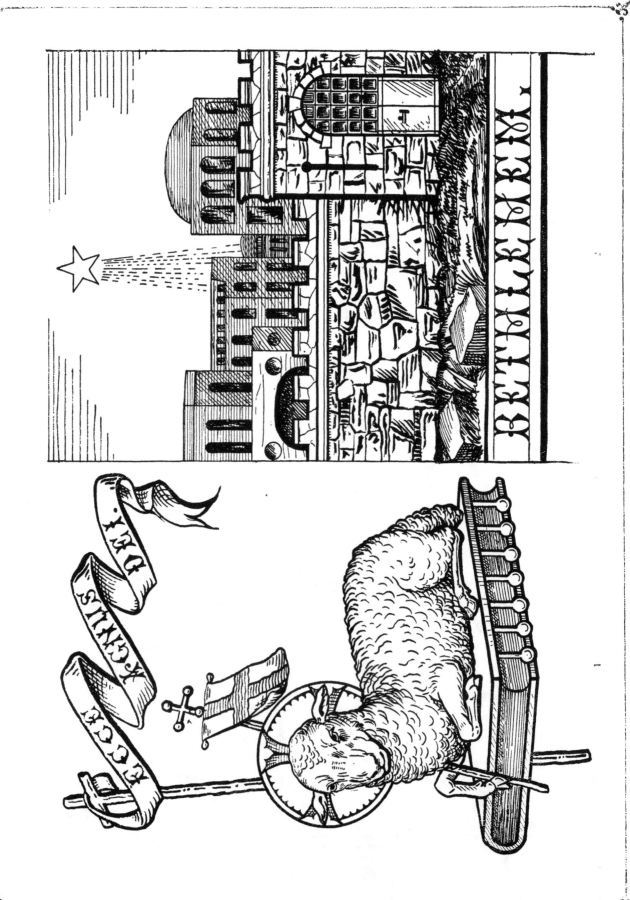

Plate XXVIII SYMBOLS AND EMBLEMS

(1)

Emblems of St. John, the forerunner of Christ.

St. John is represented with the banner, inscribed "Ecce Agnus Dei"— "Behold the Lamb of God"— (this is arranged to suit space or subject); he also bears the lamb on the book with the seven seals; the lamb bears the glorified banner.

" The voice of him that crieth in the wilderness, Prepare ye the way of the Lord, make straight in the desert a highway for our God."

Isaiah xl : 3.

"As it is written in the prophets, Behold, I send my messenger before thy face, which shall prepare thy way before thee."

Mark i : 2.

" The next day, John seeth Jesus coming unto him, and saith, Behold the Lamb of God, which taketh away the sin of the world!"

John i : 29.

(2)

Bethlehem.

" Now when Jesus was born in Bethlehem of Judea, in the days of Herod the King, behold, there came wise men from the east to Jerusalem,

" Saying, Where is he that is born King of the Jews? for we have seen his star in the east, and are come to worship him."

Matthew ii : 1, 2.

" When they had heard the king, they departed : and, lo, the star, which they saw in the east, went before them, till it came and stood over where the young child was.

" When they saw the star, they rejoiced with exceeding great joy."

Matthew ii : 9, 10.

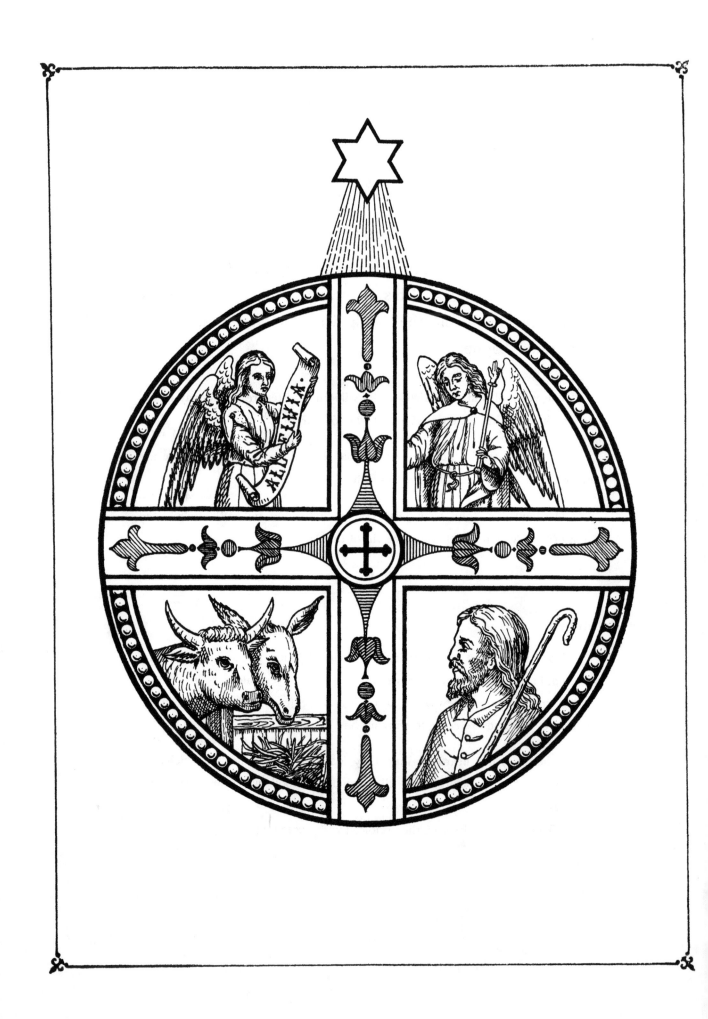

Plate XXIX SYMBOLS AND EMBLEMS

The Nativity

Emblem of the Nativity, taken as a whole; but subdivided we have:—

The Passion Cross surrounded by a circle, which means "eternal salvation." The cross divides the field of the circle into four equal parts.

The upper right hand corner suggests the Annunciation, having in it the Angel Gabriel with the sceptre.

In the upper left corner is the Praise Angel, with the inscription "Alleluia."

The adoring Shepherd is in the lower right corner.

The lower left corner signifies the humility of Christ's birth on earth.

In the centre of the Passion Cross is the Glorified or Triumphant Cross, signifying Christ's victory over sin and death.

NOTE.—The star above the circle is six-pointed, or the Creator's Star.

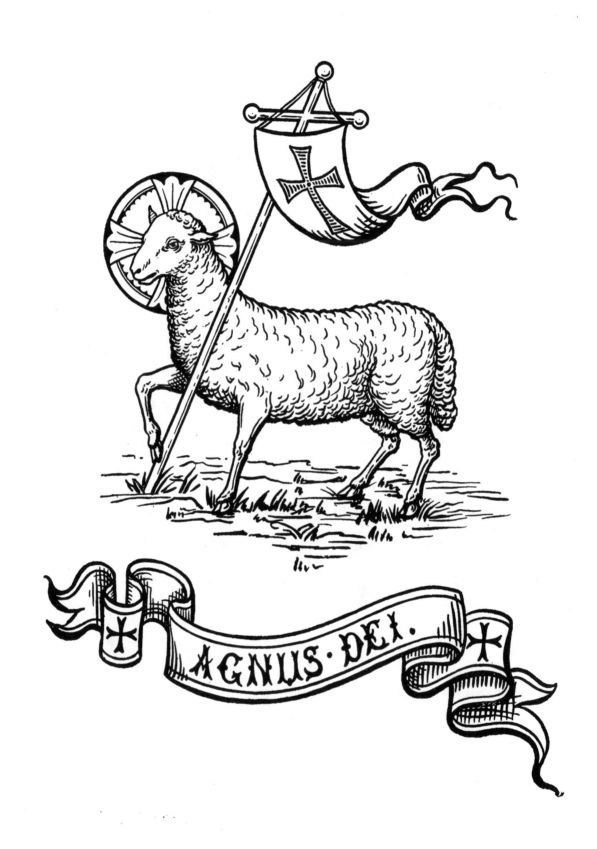

AGNUS·DEI.

Plate XXX SYMBOLS AND EMBLEMS

𝕬gnus 𝕯ei, 𝕷amb of 𝕲od

" And looking upon Jesus as he walked, he saith, Behold the Lamb of God ! "

John i : 36.

This was a favorite emblem of early Christianity.

The lamb is usually represented standing on a rock, out of which issue four streams of water, one flowing to the north, one flowing to the south, one flowing to the east, and one flowing to the west,—said to represent that the gospel should be carried to the four quarters of the globe.

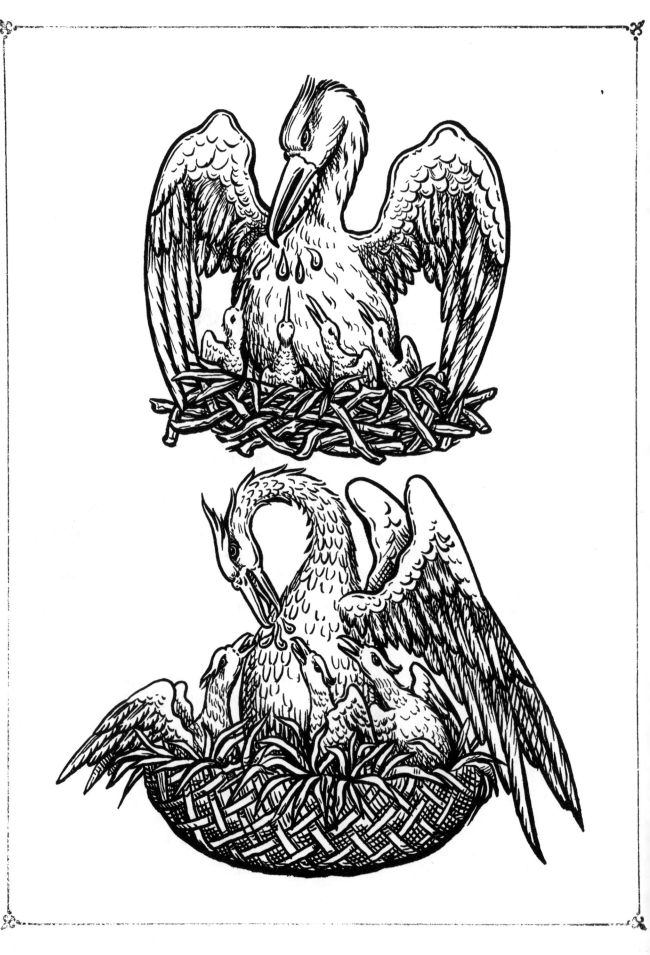

Plate XXXI SYMBOLS AND EMBLEMS

Pelicans

The pelican (of which two types are shown) has long been a favorite emblem of our Lord shedding His blood for the Church; and though the once popular belief that the pelican shed its blood for its young, has long since been proven false, the emblem is still in frequent use.

While not directly connected with the subject, the following may be of interest to the reader.

The word for God in the different languages of the world:

English—God.	Romany—Dumudden.	Turkish—Aliha.
German—Got or Gott.	Welsh—Dury.	Syriac—Eloah.
French—Dieu.	Gaelic—Dia.	Maltese—Alla.
Italian—Iddio.	Irish—Ozsi.	Persian—Khoda.
Spanish—Dios.	Manx (Isle of Man)—Jee.	Japanese—Kami.
Portuguese—Deos.	Breton—Doue.	Eskimos—Gudib.
Grecian—Dei.	Danish and Swedish—Gud.	Finnish—Jumaia.
Dutch—God.	Icelandic—Godh.	Servian—Lory.
Upper Wendish—Boh.	Surinam—Gado.	Gothic—Guth.
Lower Wendish—Bohg.	Assyrian—Llu.	Crotian—Bogu.
Albanian (Gheg)—Parandia.	Aramaic—Elath.	Slovenian—Bog.
Albanian (Tosk)—Heutvia.	Hebrew—El or Elhoim.	Afghan.—Chudai.
Catalan—Deu.	Basque—Seme.	Hind.—Khooda.
Piedmontese—Iddieu.	Slavonic—Erz.	Bohemian—Bun.
Creolese of West Indies—Godt.	Laplander—Jubmel.	Bulgarian—Etoz.
Samoiedes of Russia—Kudai.	Chinese of King Po—Jing Ming.	Latin—Deus.

Plate XXXII SYMBOLS AND EMBLEMS

Christ the Shepherd

As the hand and the arm show the power of the Father, so the arms of the Son show his love and care for the lambs.

" He shall feed his flock like a shepherd; he shall gather the lambs with his arm, and carry them in his bosom, and shall gently lead those that are with young."

Isaiah xl : 11.

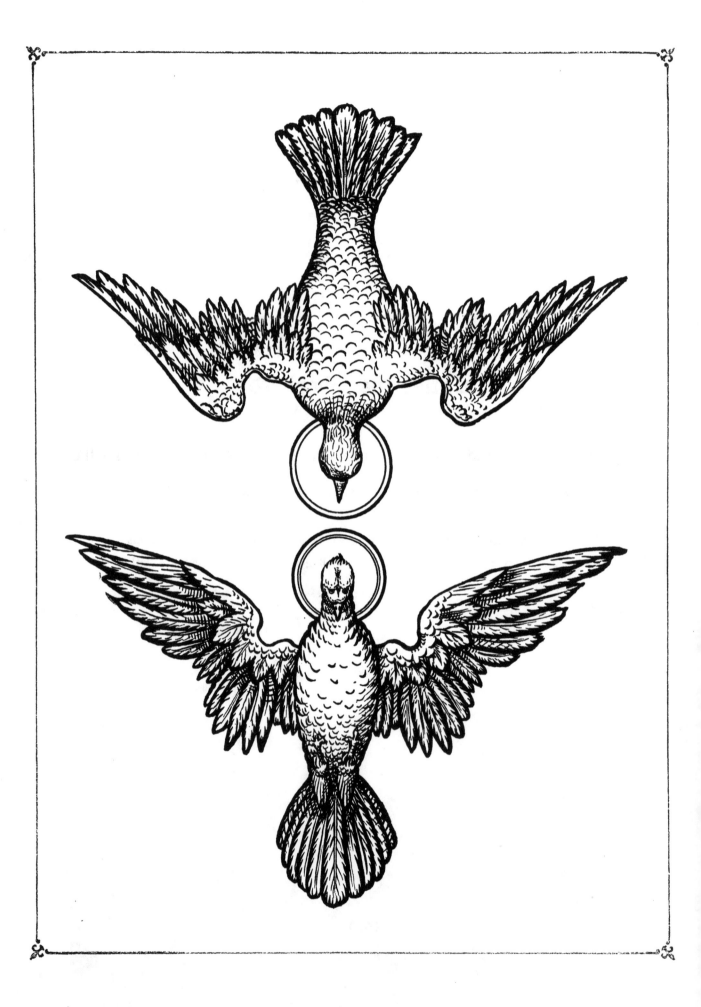

Plate XXXIII SYMBOLS AND EMBLEMS

Ascending and Descending Doves

Dove; symbol of God the Holy Spirit.

This is the regular conventional treatment. Formerly, church decorators generally placed this symbol in a central position and kept to the conventional drawings, but there has been a strong disposition of late years to make this dove more natural (as on Plate xiii). The dove is sometimes used as an emblem of the resurrection; it is then called the ascending or resurrection dove.

"And straightway coming up out of the water, he saw the heavens opened, and the Spirit, like a dove, descending upon him."

Mark i: 10.

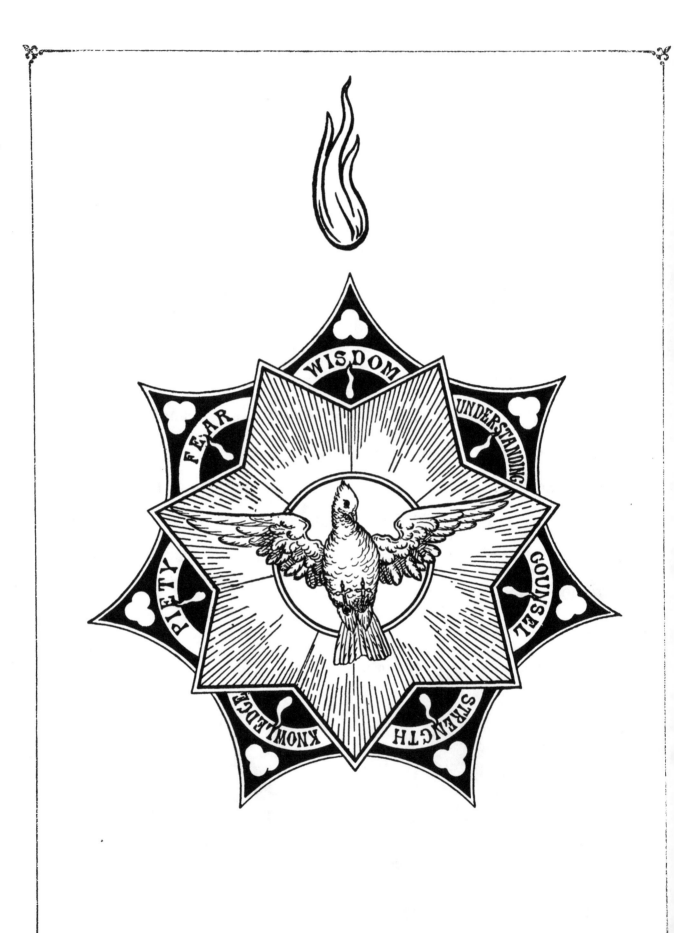

Plate XXXIV SYMBOLS AND EMBLEMS

𝔈mblems and 𝔊ifts of the 𝔇ivine 𝔖pirit

The Dove and the Tongue of Fire, in a circle; emblematic of the eternity and perfection of the Holy Ghost. These are contained in a seven-pointed star (also perfection), which is surrounded by a seven-segmented form, each segment containing one of the gifts of the Divine Spirit.

The Cloven Tongue of Flame; emblematic of the activity of the gift proceeding from the Holy Spirit, and also containing the trefoil, showing the Divine Spirit as one of the persons of the Triune God.

" Saying with a loud voice: The Lamb that was slain is worthy to receive power, and divinity, and wisdom, and strength, and honour, and glory, and bene-diction."

Apocalypse v: 12. D.

"And the spirit of the Lord shall rest upon him: the spirit of wisdom, and of understanding, the spirit of counsel, and of fortitude, the spirit of knowledge, and of godliness.

"And he shall be filled with the spirit of the fear of the Lord."

Isaias xi: 2, 3. D.

"And there appeared to them parted tongues as it were of fire, and it sat upon every one of them."

Acts ii: 3. D.

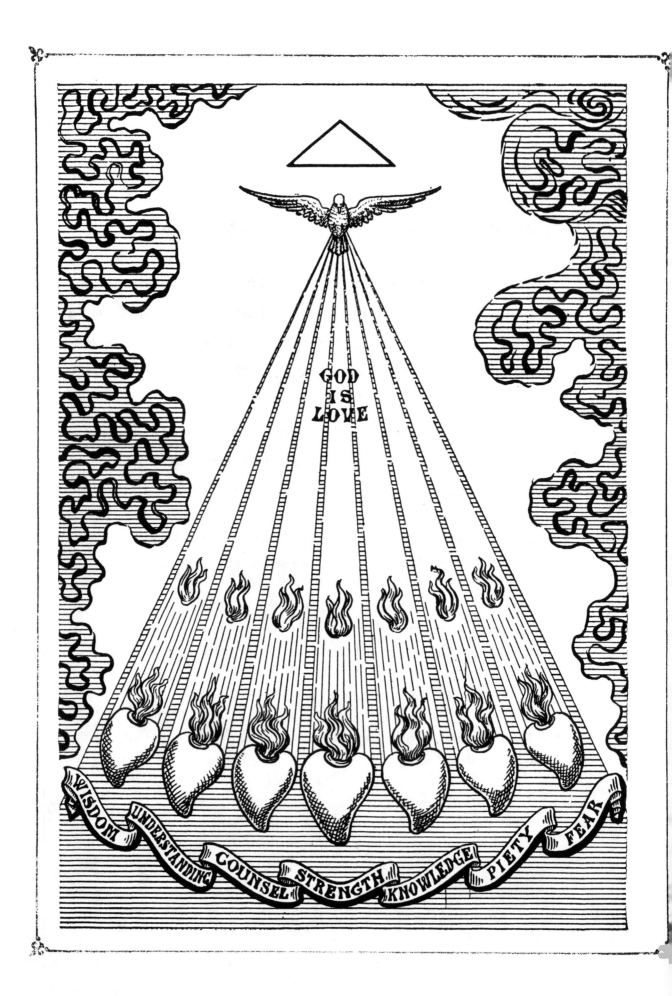

Plate *XXXV*

SYMBOLS AND EMBLEMS

The Gifts and Indwelling of the Holy Spirit

"That Christ may dwell by faith in your hearts; that being rooted and founded in charity."

Ephesians iii : 17. D.

This, as well as the foregoing emblem, may be differently arranged, but care should be taken that *wisdom* has the first or most prominent position.

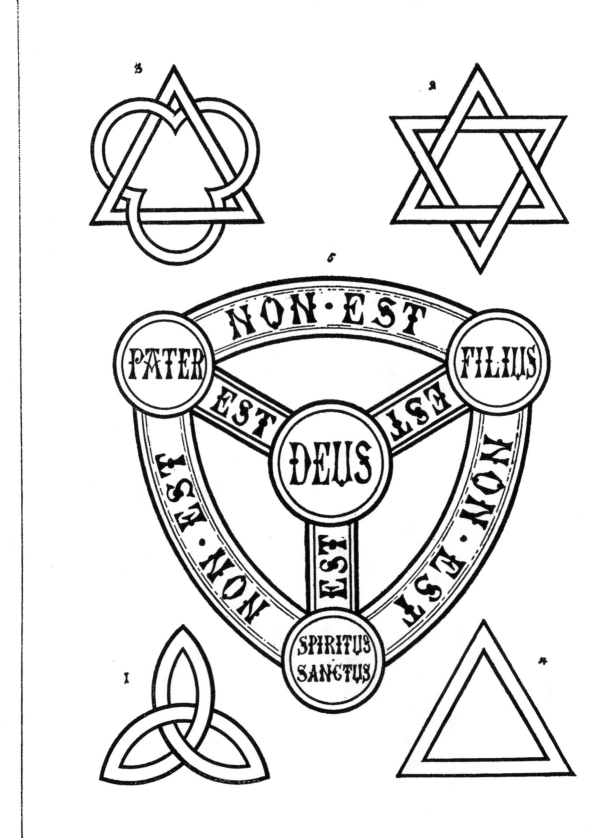

Plate XXXVI SYMBOLS AND EMBLEMS

𝔈mblems of the 𝔗rinity

"For there are three that bear record in heaven, the Father, the Word, and the Holy Ghost: and these three are one."

1 John v: 7.

(1)

The Triquetra, formed by the interlacing of three equal portions of circles, is much used in the Western Church, and is frequently found on Celtic crosses.

(2)

The Double Triangle is much used in the Greek Church, and is said to express the Trinity and Infinitude of the Godhead.

(3)

Triangle interlaced with three segments of a circle.

(4)

The Equilateral Triangle is the usual emblem of the Godhead.

(5)

The lettered emblem shows that the Father is not the Son, the Son is not the Holy Spirit, and the Holy Spirit is not the Father; and that the Father is God, the Son is God, and the Holy Spirit is God.

NOTE.—All similar portions of the same form are equal in size, except the centre circle, containing the word God, which is always made larger than the other three circles.

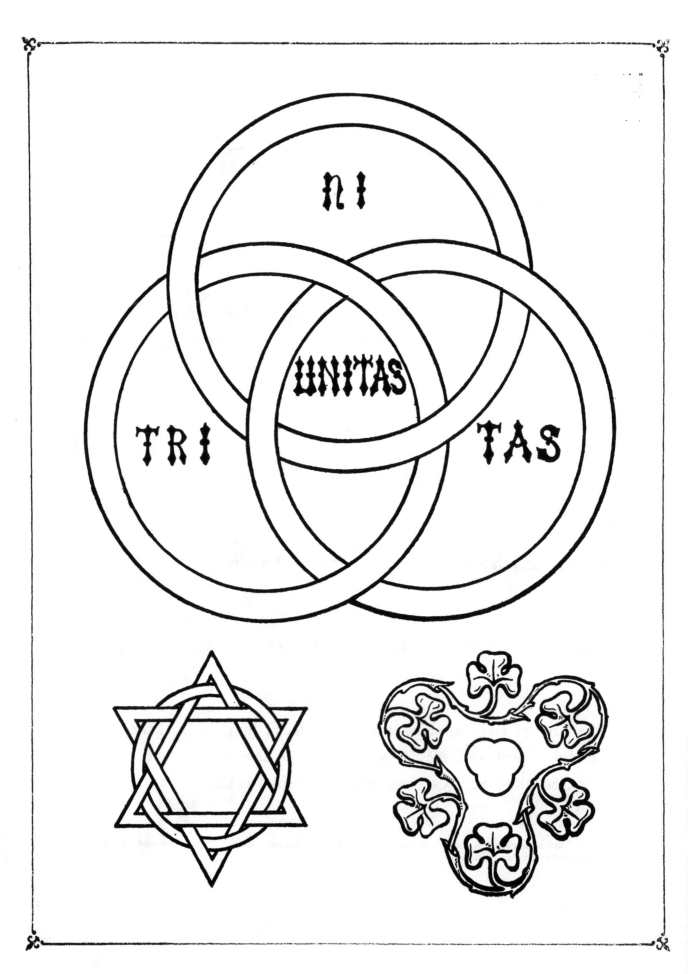

Plate XXXVII SYMBOLS AND EMBLEMS

Emblems of the Trinity
(*Continued.*)

(I)

The circle is emblematic of God and perfection — without beginning, without end.

Three circles — three persons. The three circles are interlaced, representing the union.

The word "Trinitas" is divided into three syllables, one syllable placed in each circle. In the centre space, formed by the intersection of the three circles, is the word "Unitas." Unity is the centre from which radiates the Trinity.

(2)

Double interlacing triangle, interlaced also with the circle. This form is said to represent the eternity and the perfection of the Trinity.

(3)

A conventional treatment of the shamrock.

The shamrock is a natural illustration, used by St. Patrick, in Ireland, to convince his hearers of the feasibility of the doctrine of the Trinity, when derided for proclaiming it.

There are several other ways of representing the Trinity, amongst which may be mentioned the combination of the Hand, the Father; the Lamb, the Son; the Dove, the Holy Spirit. The early Christians used three fishes variously placed.

Probably enough illustrations have been given.

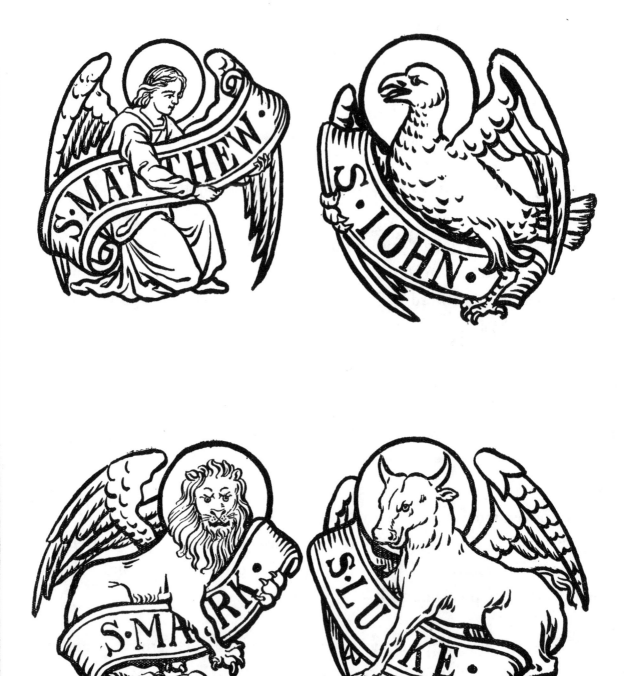

Plate XXXVIII SYMBOLS AND EMBLEMS

Symbols of the Four Evangelists

"As for the likeness of their faces, they four had the face of a man, and the face of a lion, on the right side ; and they four had the face of an ox on the left side ; they four also had the face of an eagle."

Ezekiel i : 10.

Matthew is represented as a man, because he dwells more upon the human than the divine nature of our Lord.

Mark is represented as a lion, because he commences his gospel with the voice of one crying in the wilderness.

The lion is an emblem of the royal dignity of Christ.

"Behold, the Lion of the tribe of Juda."

Revelation v : 5.

Luke is represented as an ox, because he writes more of the priesthood of Christ.

The ox is the symbol of sacrifice.

John is represented as an eagle, because of his lofty flights of inspiration.

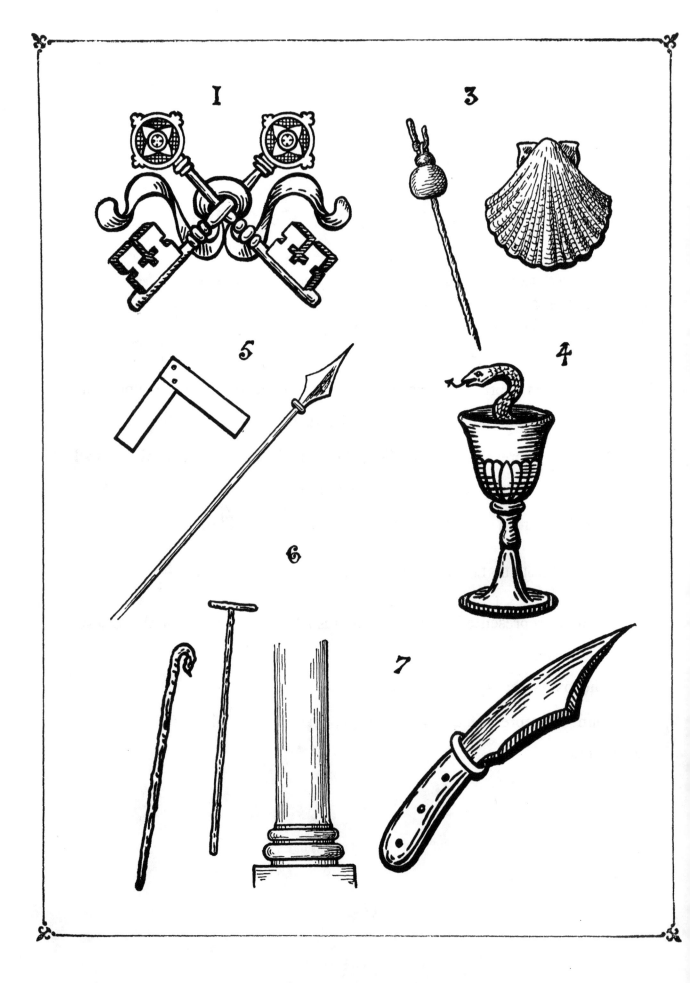

Plate *XXXIX* SYMBOLS AND EMBLEMS

The Twelve Disciples

(1)

Peter (a rock or stone) was recognized as the leader of the Twelve Disciples. He was crucified by order of Nero, A.D. 67, at Rome. Origen says that Peter felt himself to be unworthy to be put to death in the same manner as his Master, and was, therefore, at his own request, crucified with his head downward.

The emblems of St. Peter are the crossed keys, one gold and one silver.

> "And I will give unto thee the keys of the kingdom of heaven : and whatsoever thou shalt bind on earth, shall be bound in heaven ; and whatsoever thou shalt loose on earth, shall be loosed in heaven."
>
> *Matt. xvi : 19.*

Also, the cock, on account of Peter's denial of his Master.

> "And he said, I tell thee, Peter, The cock shall not crow this day, before that thou shalt thrice deny that thou knowest me."
>
> *Luke xxii : 34.*

(2)

Andrew (manly), brother of Peter. Tradition says he was crucified at Patrae in Achaia.

The emblem of St. Andrew is the cross, called St. Andrew's Cross. (See Plate lxxxii.)

The Twelve Disciples

(Continued.)

(3)

James the Great (supplanter) was put to death by Herod Agrippa in A.D. 44. After his call, Christ gave James and John the name of Boanerges (sons of thunder). James was the first martyr among the disciples.

The emblems of St. James are the pilgrim's staff and water bottle; also, escalloped shell. The shell is used as an emblem of pilgrimage and also as an emblem of baptism.

(4)

John (Jehovah's gift) was called the beloved disciple. He was brother of James the Great, and was, with him, given the name Boanerges. John was thrown in a cauldron of boiling oil, from the effects of which he was miraculously preserved. The date of John's death is uncertain. He was the only disciple who died a natural death.

St. John's emblem is a serpent issuing from a chalice. Tradition says that a priest of Diana challenged him to drink from a poisoned cup. He made the sign of the cross over it, and Satan, in the form of a serpent or dragon, flew from the cup.

The Twelve Disciples
(Continued.)

(5)

Thomas (a twin), the doubting disciple. He is supposed to have suffered martyrdom by a lance, at Coromandel, India, where there are still Christian churches which are called by his name.

The emblem of St. Thomas is a lance, also a carpenter's square. The illustration is a square, called a carpenter's rule by all writers; but it is invariably shown as illustrated.

(6)

Philip (lover of horses) suffered death by being suspended from a lofty column at Hierapolis.

Emblems of St. Philip are the column and long staff. Two types of staff are given, one in the form of the Tau Cross, which is also known as St. Anthony's Cross.

(7)

Bartholomew (probably Nathanael), called by Christ "an Israelite without guile." Some authorities assert he was crucified, but most writers claim he was flayed alive; hence, his emblem, a large knife.

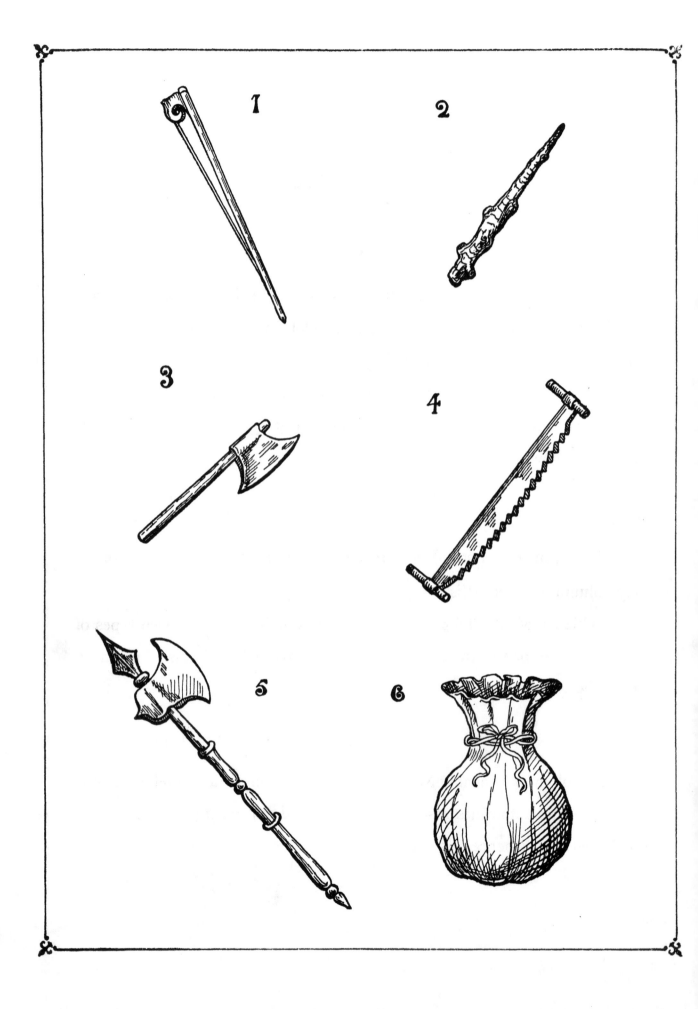

The Twelve Disciples

(Continued.)

(1)

James the Less (called so on account of his being smaller and younger than James the Great). Tradition says James was thrown down from the temple by scribes and Pharisees; he was then stoned and his brains dashed out with a fuller's club.

(2)

Jude—Lebbeus Thaddeus (a man of heart), brother of James the Less, is supposed to have been martyred at Berytus about 80 A.D., with a club. The emblem of St. Jude is a knotted club; some authorities give him a halberd.

(3)

Matthew (gift of Jehovah) was put to death in Parthia with a hatchet; hence he is occasionally represented with a hatchet and sometimes with a purse or money-bag, as he had formerly been a receiver of taxes.

(4)

Simon the Canaanite (a hearing) suffered martyrdom in Persia by a saw. The emblem of St. Simon is a saw.

(5)

Matthias (gift of God) was elected to fill the place among the twelve left vacant by Judas. Matthias suffered martyrdom in Ethiopia by a battle-axe. The battle-axe is the emblem of St. Matthias. Sometimes the lance is used as his emblem.

(6)

Judas Iscariot (a Greek form of the Hebrew name Judah, meaning praised, celebrated), the betrayer of Christ. As Judas was treasurer of the twelve disciples, his emblem is a money-bag.

Following are the lists of the Twelve Disciples as the Latin and Greek Churches have them:

LATIN LIST.		GREEK LIST.	
St. Peter.	St. James the Less.	St. Matthew.	St. Andrew.
St. Paul.	St. Philip.	St. Philip.	St. Thomas.
St. Andrew.	St. Bartholomew.	St. Mark.	St. Simon.
St. James the Great.	St. Matthew.	St. Paul.	St. Bartholomew.
St. John.	St. Simon.	St. Peter.	St. James the Great.
St. Thomas.	St. Matthias.	St. Luke.	St. John.

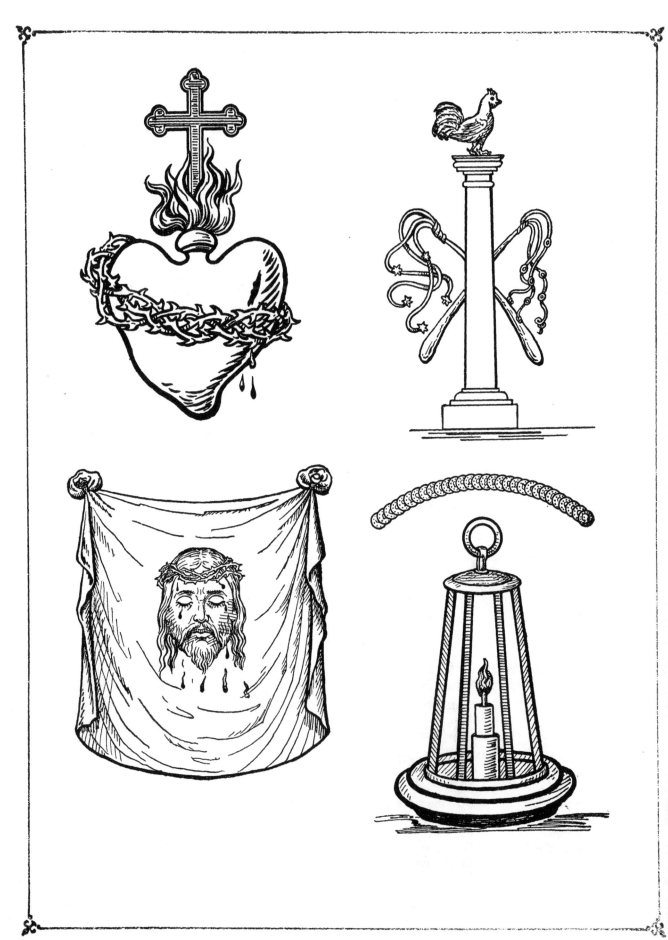

Plate XLI SYMBOLS AND EMBLEMS

Emblems of the Passion

Pope Innocent VI (1352–1362) affirmed, in a decree, that the lance, nails and other instruments of the Passion are everywhere to be held in reverence of all Christian people, and instituted a religious festival in their honor. There is no set order for the use of these emblems, but so far as practical, I would suggest their being used in their Scriptural order. They are very rarely all used in one church.

The emblems of the Passion can be arranged or combined in a great variety of forms.

(1)

The Sacred Heart of Jesus.

The flames represent the burning love of Christ for the world; out of the flames issues the cross, symbolical of his death and glory.

The crown of thorns encircles the heart.

(2)

Column, Scourge and Cock.

In this connection, the cock is used on account of the prediction of our Lord, that it should not crow until Peter had denied him thrice.

Scourging was a common form of punishment among the Jews.

See Matthew xxvii : 26; Mark xv : 15; John xix: 1.

The cock is also emblematic of watchfulness and alertness.

See Matthew xxvi : 34; Mark xiv : 30; Luke xxii : 34; John xiii : 36.

(3)

The St. Veronica.

The name Veronica, from " Vera icon," the true image, i.e., of Christ, was said to have been given to a woman, who, when Jesus was passing her house on the way to Calvary, wiped His face with a handkerchief, and, as a reward for her love, He left the impression of His face upon the handkerchief.

(4)

The Thirty Pieces of Silver.

Judas sold our Lord for thirty pieces of silver (i.e., 3£ 10s. 8d., $16.96), the legal value of a slave if he were killed by a beast.

See Matthew xxvi : 15; Matthew xxvii : 3; Mark xiv : 2.

(5)

Lantern.

They went to seek Jesus with lanterns. *See John xviii : 3.*

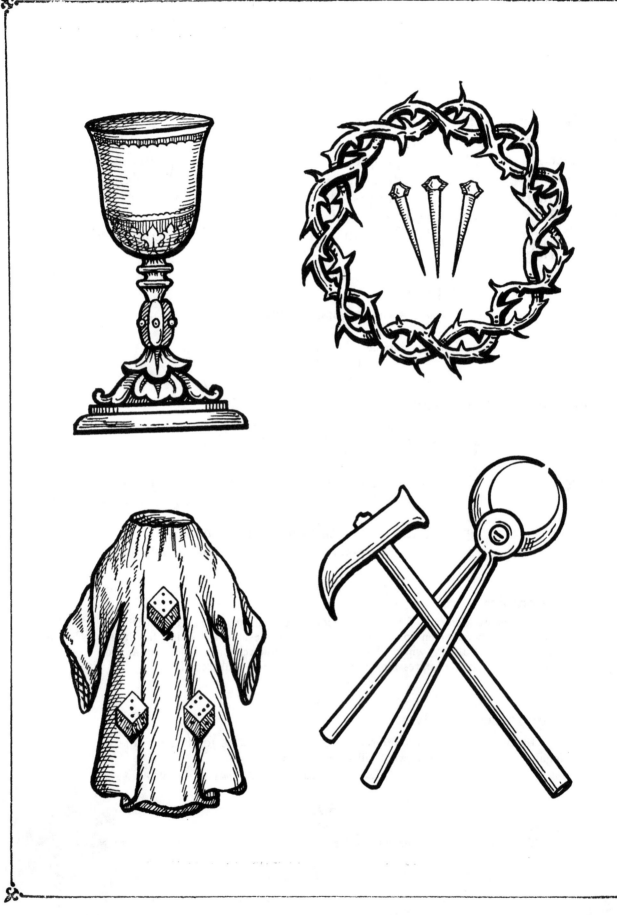

Emblems of the Passion
(*Continued.*)

(1)

Chalice.*

" If it be possible, let this chalice pass from me."

Matthew xxvi: 39. (See also Mark xiv : 36.) D.

(2)

Crown of Thorns; Nails.

See Matthew xxvii: 29; Mark xv: 17; John xix : 2; John xx: 25.

(3)

Coat without seam.

See Matthew xxvii: 35; Mark xv: 24; John xxiii: 24.

(4)

Hammer and Pincers; used as emblems of the Passion.

*NOTE.—Be sure, in illustrating the emblems of the Passion, not to use either the wafer or the paten with the chalice; as this chalice illustrates, not the Lord's Supper, but the full measure of our Lord's suffering.

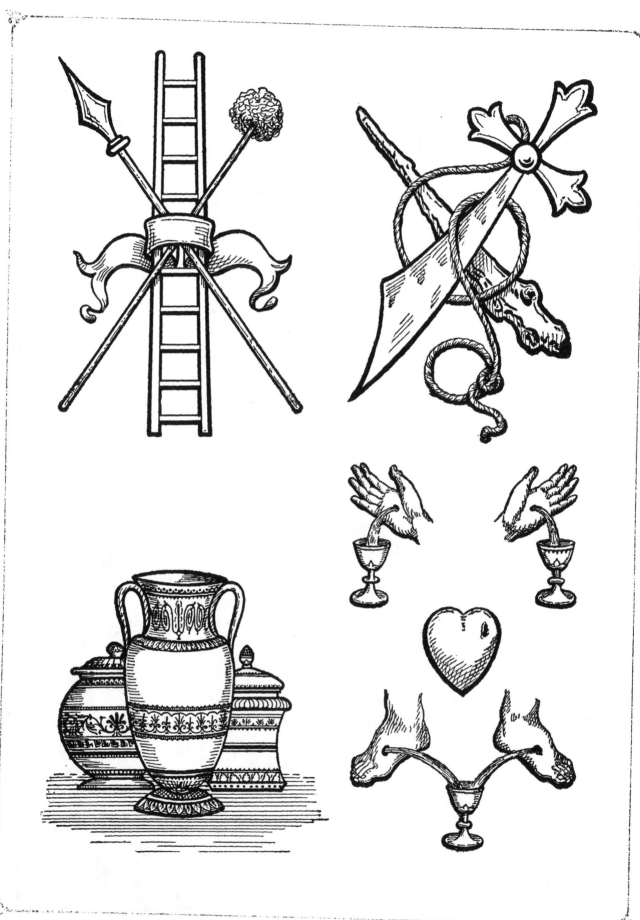

Plate *XLIII*

SYMBOLS AND EMBLEMS

Emblems of the Passion

(*Continued.*)

(I)

Ladder, Sponge and Spear.

"And immediately one of them running took a sponge, and filled it with vinegar; and put it on a reed, and gave him to drink."

Matthew xxvii: 48. (*See also Mark xv: 36; John xix: 29.*) *D.*

" But one of the soldiers with a spear opened his side."

John xix: 34. D.

(2)

The Rope of Judas.

" And went and hanged himself with an halter."

Matthew xxvii: 5. D.

The Sword of Peter.

"Then Simon Peter, having a sword, drew it, and struck the servant of the high priest, and cut off his right ear. And the name of the servant was Malchus."

John xviii: 10. (*See also Matthew xxvi: 51; Luke xxii: 50, 51.*) *D.*

Sometimes the ear of Malchus is shown; this may be because its healing was the last miracle performed by Christ before the Crucifixion.

(3)

Boxes of Ointment.

"And Nicodemus also came, (he who at the first came to Jesus by night,) bringing a mixture of myrrh and aloes, about an hundred pound weight."

John xix: 39. D.

(4)

Represents the five wounds of Christ.

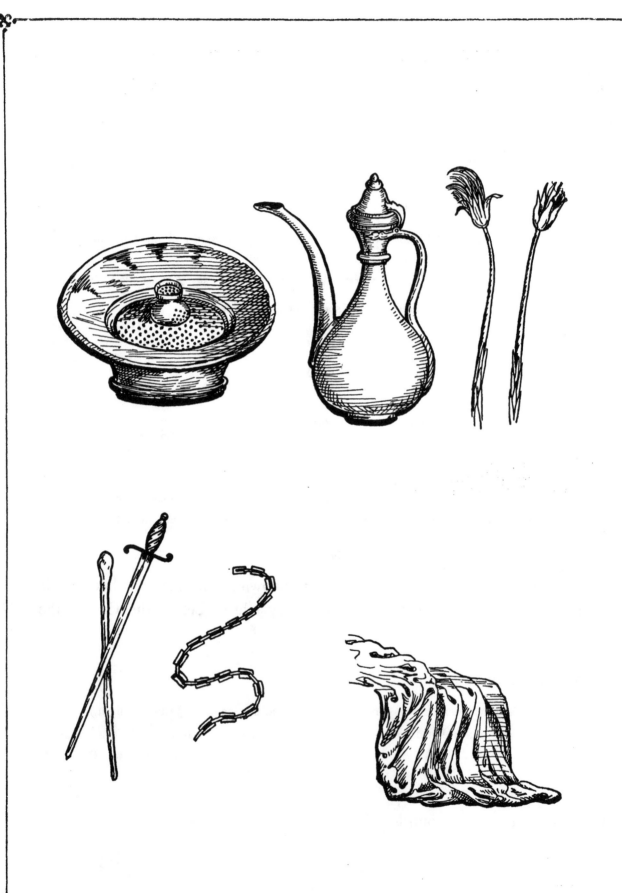

Plate *XLIV* SYMBOLS AND EMBLEMS

𝔈mblems of the 𝔓assion

(*Continued.*)

(1)

Basin and Water Pot.

> "And Pilate taking water washed his hands before the people."
>
> *Matthew xxvii : 24. D.*

(2)

Reed.

> " And platting a crown of thorns, they put it upon his head, and a reed in his right hand."
>
> *Matthew xxvii : 29. D.*

(3)

Sword and Staves.

> "And while he was yet speaking, cometh Judas Iscariot, one of the twelve: and with him a great multitude with swords and staves."
>
> *Mark xiv : 43. (See also Matthew xxvi : 47.) D.*

(4)

Chain.

> "And they brought him bound."
>
> *Matthew xxvii : 2. D.*

(5)

Linen, in which they wrapped the body of Jesus.

> " And Joseph taking the body, wrapped it up in a clean linen cloth."
>
> *Matthew xxvii : 59. (See also Mark xv : 46 ; Luke xxiii : 53 ; John xix : 40.) D.*

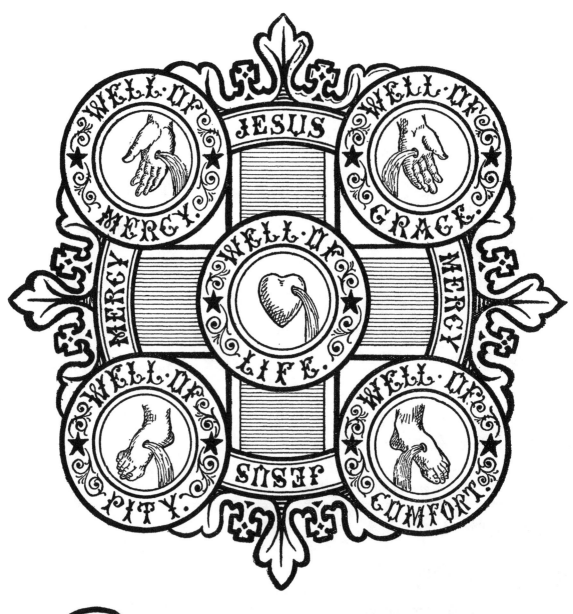

WELL·OF MERCY. WELL·OF GRACE. JESUS MERCY WELL·OF LIFE. MERCY WELL·OF PITY. JESUS WELL·OF COMFORT.

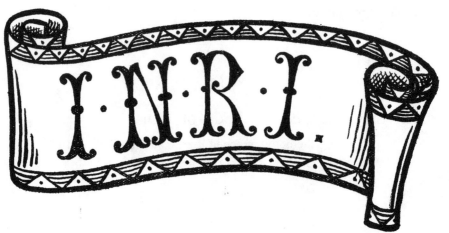

·I·N·R·I·

Plate *XLV* SYMBOLS AND EMBLEMS

𝔈mblems of the 𝔓assion
(Continued.)

(1)

A combination of the five wounds and the cross. The ends of the cross are capped with crowns.

(2)

The inscription which Pilate placed upon the cross : I. N. R. I. (Jesus of Nazareth, the King of the Jews.)

"And Pilate wrote a title also, and he put it upon the cross. And the writing was : Jesus of Nazareth, the King of the Jews."

John xix : 19. D.

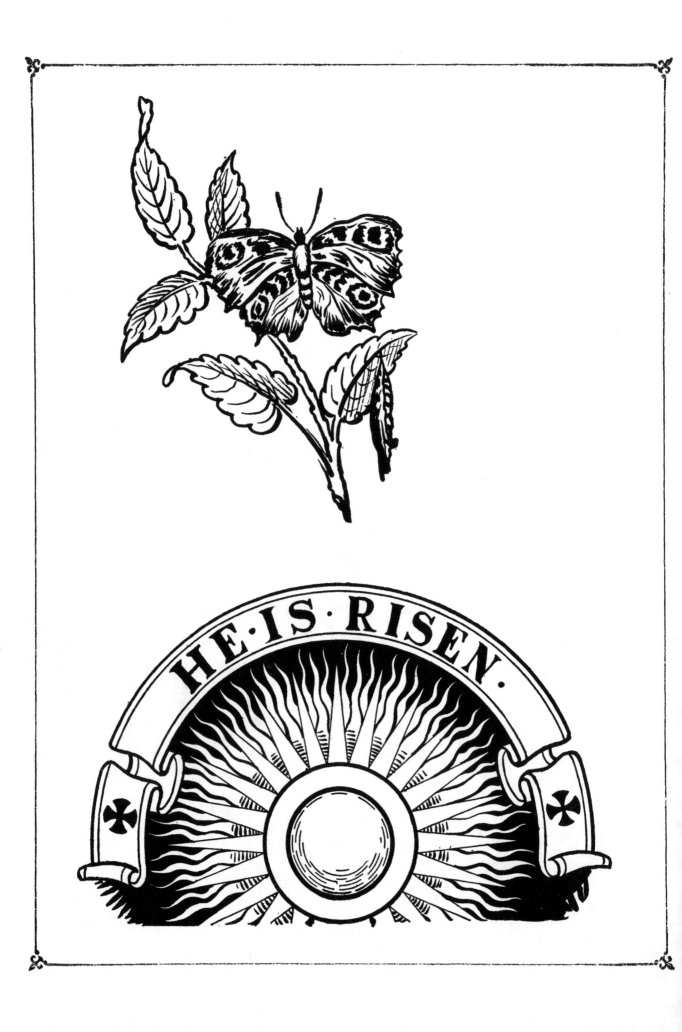

Plate XLVI

SYMBOLS AND EMBLEMS

𝕰mblems of the 𝕽esurrection

(1)

Butterfly and Chrysalis.

> " Jesus said unto her, I am the resurrection, and the life : he that believeth in me, though he were dead, yet shall he live."
>
> *John xi : 25.*

(2)

The Rising Sun, surmounted by the inscription " He is Risen."

> *See Mark xvi : 6.*

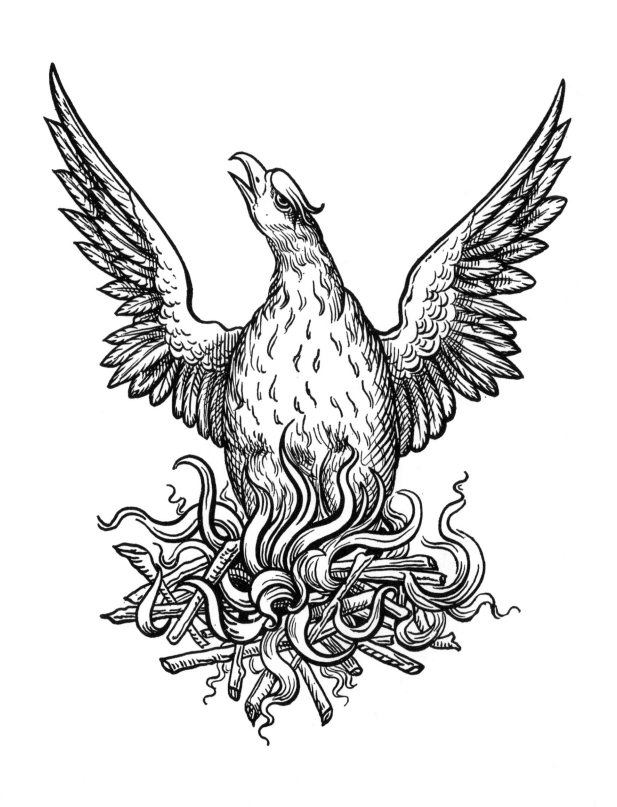

Plate *XLVII* SYMBOLS AND EMBLEMS

Phenix

Emblem of Immortality and Resurrection.

A fabulous bird of antiquity ; was said to be like the eagle in form and size, but of very beautiful and vivid plumage, mostly gold colored and crimson.

Amongst the Egyptians it was the emblem of the soul. It was said to live about six hundred years, then to make a pyre of aromatic gums and spices, light the pile with the fanning of its wings, then to be consumed ; and from its ashes it arose, reinvigorated and with its youth renewed. Although this myth has long since been proven false, the Phenix is still a favorite emblem.

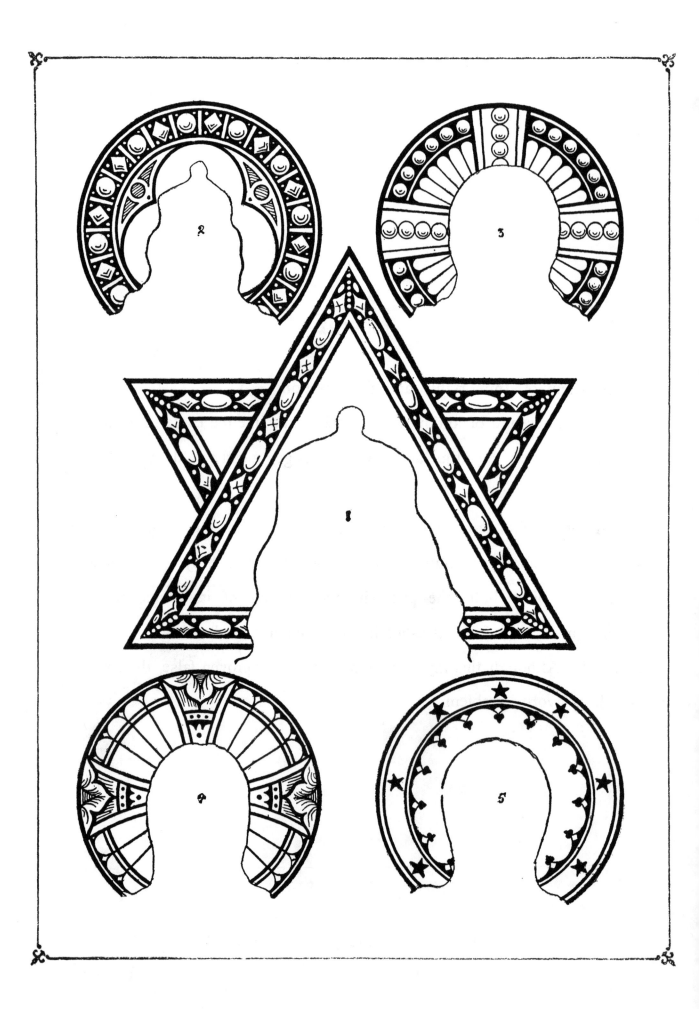

Plate XLVIII SYMBOLS AND EMBLEMS

Nimbi

The nimbus, like the crown, shows the rank. Generally speaking, the more ornamental and decorative the nimbus is made, the higher the rank.

The nimbus of the Divinity is always the most ornamental, and that of the Blessed Virgin is next. Some exceptions may occur in elaborate pictures of saints, when they are pictured in churches which bear their names.

The nimbus is the light, halo, or glory surrounding the heads of the Divinity, angels, saints, etc., the various forms of which have their proper application and meanings.

(1)

Nimbus of God the Father. This is a double triangle, one being set in front of the other. The triangle is probably the oldest known emblem of the Trinity.

> This form of the nimbus is confined almost exclusively to God the Father, very rarely given to God the Son, or God the Holy Ghost; and never to a saint.

(2)

A circular form of nimbus of God the Father, containing the trefoil, emblematic of the Trinity.

(3 and 4)

Cruciform Nimbus.

> This is nearly always the recognized nimbus of the crucified one, i.e., Jesus Christ, but is occasionally found depicted in pictures of God the Father, and is more frequently found on the dove, representing the Holy Ghost, and is sometimes by error placed around the heads of saints.

(5)

Nimbus of the Blessed Virgin.

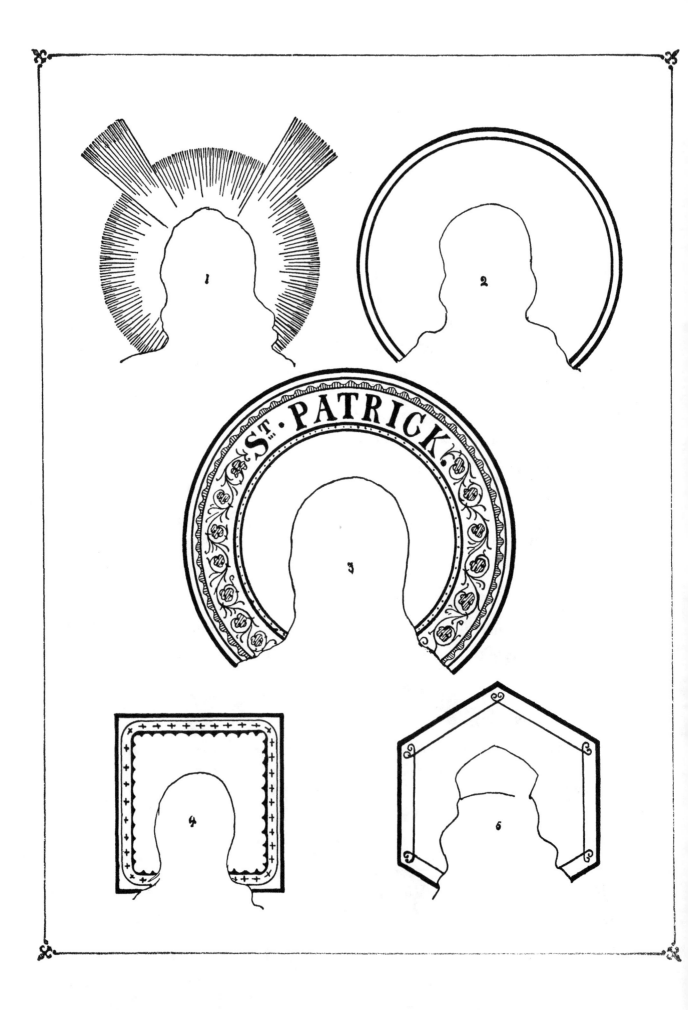

𝔑𝔦𝔪𝔟𝔦

(Continued.)

(1)

Nimbus of Moses.

> " And they saw that the face of Moses when he came out was horned,* but he covered his face again, if at any time he spoke to them."
>
> *Exodus xxxiv : 35. D.*

(2)

A form frequently used for all saints, and occasionally on the figures of our Lord and Blessed Virgin.

(3)

A style of nimbus not often used in this country, but frequently employed throughout Europe and more especially in Germany.

(4)

Form of nimbus used when pictures of living persons are placed in churches.

(5)

Generally used when prophets and allegorical figures are represented.

> In the west the nimbi are used exclusively when biblical or religious characters are represented, but in the east, and also in Rome before the time of Constantine, those who were distinguished for any thing or in any way were represented with a nimbus.
>
> The nimbus should be of a bright yellow color; that of Judas, of a dead or dirty yellow, while Satan is represented bearing a black nimbus.
>
> When the glory surrounds the entire figure it is called the aureole. It is usually confined to figures of the Deity, occasionally given to the Blessed Virgin, especially if she holds the Infant Jesus. Its form generally has no signification.

* Horned : that is, shining, sending forth rays of light.

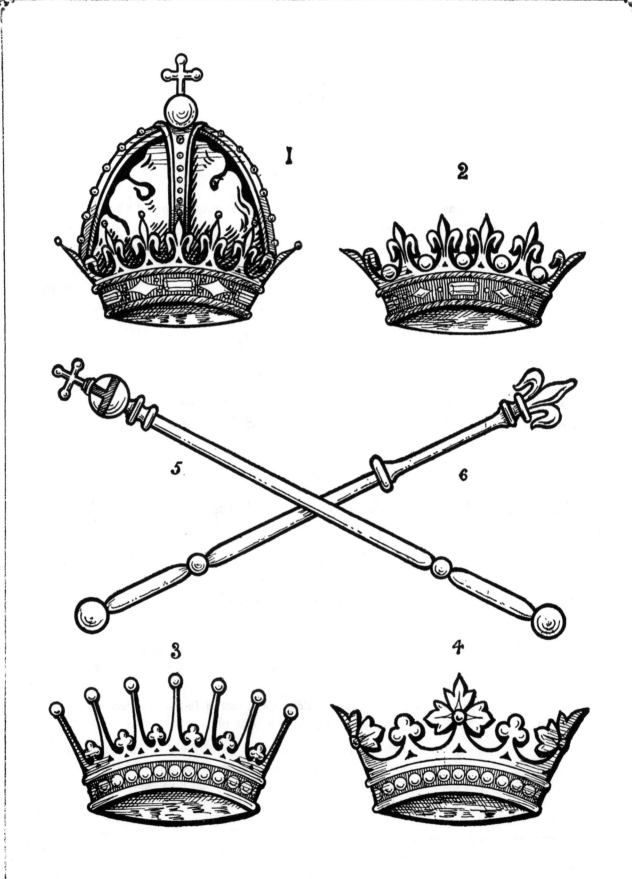

Plate L SYMBOLS AND EMBLEMS

Crowns and Sceptres

(1)

Crown of the Godhead.

(2)

Crown of the Blessed Virgin.

(3 and 4)

Crowns of the Saints.

These forms of the crown are not arbitrary; other forms may be used. But crowns for the Godhead are the only ones which should be capped and arched; and should be surmounted by the globe and cross. The Virgin's crown may be capped, but not arched.

When royal personages become illustrious in the church and are pictured, the crown to which they were by rank entitled is usually shown at their feet; either in token of humility, or of the minor importance of earthly rank.

(5)

Sceptre of the Godhead.

(6)

Sceptre of the Blessed Virgin.

When it is desired to represent Father and Son in the same picture the sceptres may be varied, substituting the hand (power) for the globe and cross, for the sceptre of the Father; the sceptre of the Son remaining as No. 5.

(The crown was an outcome of the wreath; the wreath was the first form of crown known or used. The earliest known crowns were made in imitation of wreaths.)

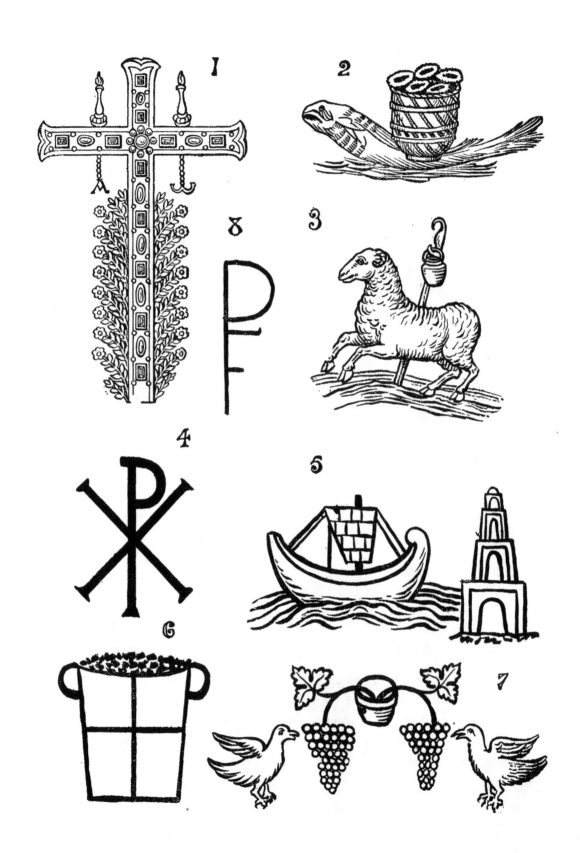

Plate LI SYMBOLS AND EMBLEMS

Emblems from the Catacombs

(1)

From the Catacomb of St. Pontiatus, Rome. It represents a jeweled cross, beautified by the rose of Sharon on either side.

On the arms are placed torches or lamps, emblematic of light and life; suspended from the arm on the left is the *A*, "Alpha, the Beginning," and on the right is the *Ω*, "Omega, the End": the whole signifying that there are beauty, riches, light and life in the cross, and that the cross represents the beginning and the end of salvation.

(2)

From the crypt of St. Lucina. It is called the Eucharistic carp, and bears on its back a basket of bread.

(3)

From the Catacomb of St. Domitta; a bounding lamb with the pastoral staff and the milk pail, emblematic of divine nurture.

(4)

The CHI RHO. From the Greek word signifying fish, the letters of which form the sacred acrostic, "Jesus Christ, Son of God, Saviour."

(5)

The ship represents the Church, and the Pharos (lighthouse), Christ, the light or guide to the peaceful harbor.

(6)

A modius, or Roman peck measure.

This occurs on tombs in the Catacombs, but is generally passed over as having no meaning. I judge it to mean a full and perfect life through the Cross.

(7)

The souls of the righteous feeding on the true Vine.

(8)

From the Julian Basilica. "Palma Felicitas" (victory won).

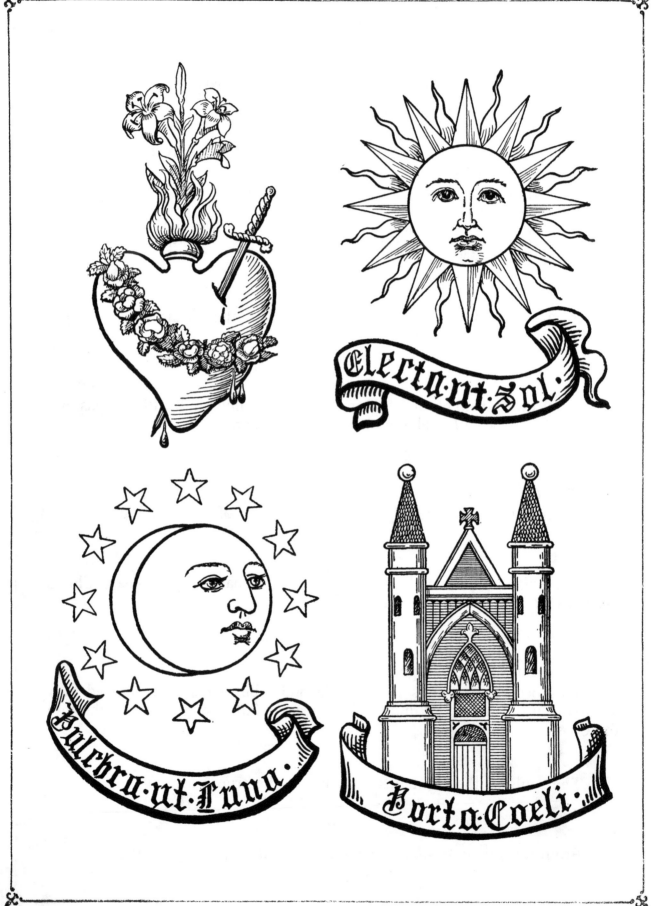

Plate LII

SYMBOLS AND EMBLEMS

Litany of the Blessed Virgin

The emblems of the Blessed Virgin are illustrated as often without as with the names. A number of illustrations of titles that are not used in the present Liturgy are shown here. These have become favorites and may be used on special occasions and under special circumstances; for instance, Mary, Star of the Sea, the Hope of the Mariner, would be appropriately used in a church by the seashore.

(1)

Heart.

"And thy own soul a sword shall pierce, that, out of many hearts, thoughts may be revealed."

Luke ii : 35. D.

(2 and 3)

Sun, Moon, and Stars.

"A woman clothed with the sun, and the moon under her feet, and on her head a crown of twelve stars."

Apocalypse xii : 1. D.

" Who is she that cometh forth as the morning rising, fair as the moon, bright as the sun."

Canticles vi : 9. D.

" Behold the handmaid of the Lord; be it done to me according to thy word."

Luke i : 38. D.

(4)

Gate of Heaven.

" Indeed the Lord is in this place, and I knew it not. . . . This is no other but the house of God, and the gate of heaven."

Genesis xxviii : 16, 17. D.

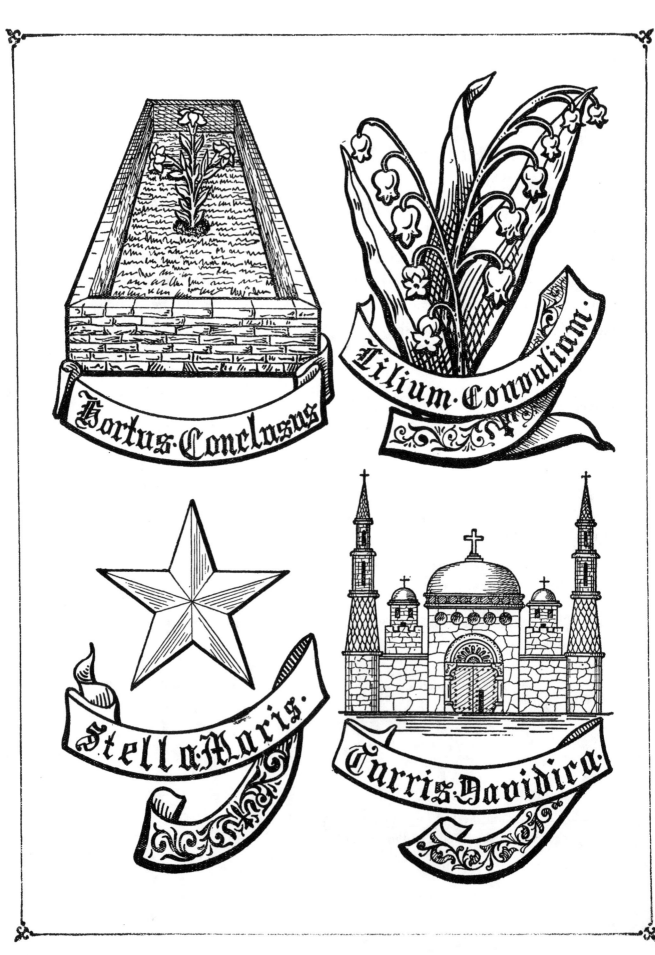

Hortus·Conclusus

Lilium·Convalium

Stella·Maris·

Turris·Davidica·

Plate *LIII* SYMBOLS AND EMBLEMS

Litany of the Blessed Virgin

(*Continued.*)

(1)

Enclosed Garden.

See Canticles iv: 12. D.

(2)

Lily of the Valley.

"I am the flower of the field, and the lily of the valleys."

Canticles ii: 1. D.

"As the lily among thorns, so is my love among the daughters."

Canticles ii: 2. D.

(3)

Morning Star.

"I Jesus have sent my angel, to testify to you these things in the churches. I am the root and stock of David, the bright and morning star."

Apocalypse xxii : 16. D.

(4)

Tower of David.

"For he is my God and my saviour: he is my protector, I shall be moved no more."

Psalms lxi: 3. D.

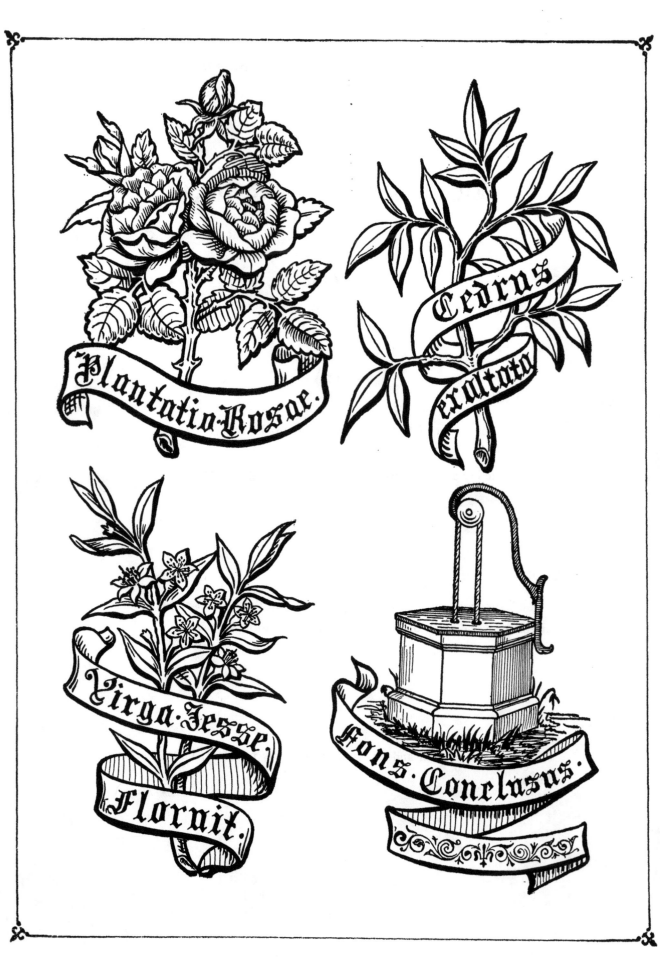

Plate LIV

SYMBOLS AND EMBLEMS

Litany of the Blessed Virgin

(*Continued.*)

(1)

Mystical Rose.

(2)

Exalted Cedar.

"I was exalted like a cedar in Libanus."

(3)

Root of Jesse.

" And there shall come forth a rod out of the root of Jesse, and a flower shall rise up out of his root."

Isaias xi: 1. D.

(4)

Enclosed Well.

" My sister, my spouse, is a garden enclosed, a garden enclosed, a fountain sealed up."

Canticles iv: 12. D.

The foliage of the root of Jesse is often that of the vine; symbolical of spiritual fruitfulness.

"I am the vine, ye are the branches."

Olive and pomegranate are also used; the illustration is myrtle.

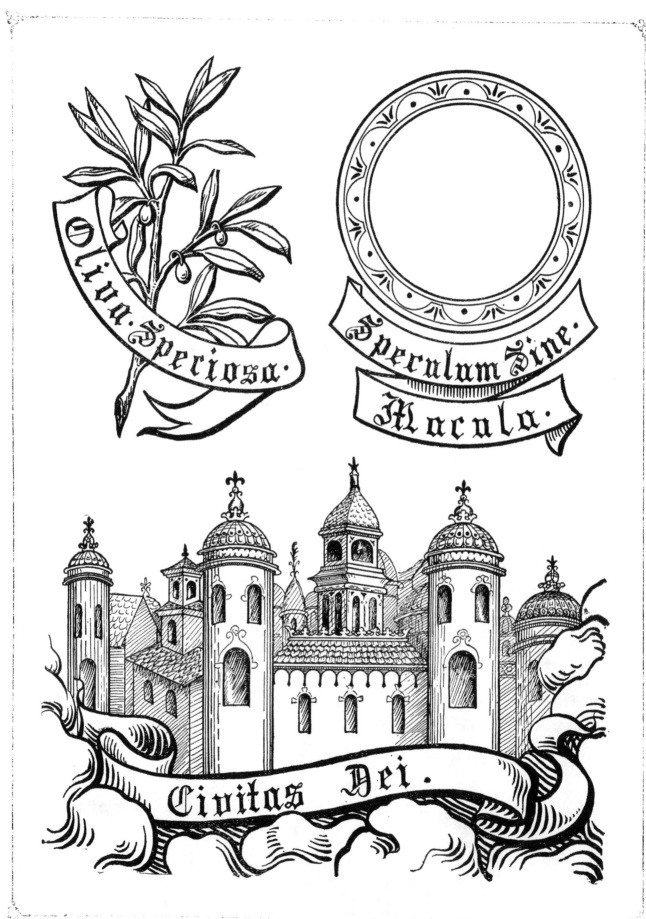

Plate LV　　　　　　　　　　　　　　　　　SYMBOLS AND EMBLEMS

𝕷𝖎𝖙𝖆𝖓𝖞 𝖔𝖋 𝖙𝖍𝖊 𝕭𝖑𝖊𝖘𝖘𝖊𝖉 𝖁𝖎𝖗𝖌𝖎𝖓

(Continued.)

(I)

Olive Branch.

(2)

Spotless Mirror.

"For she is the brightness of eternal light, and the unspotted mirror of God's majesty, and the image of His goodness."

Wisdom vii : 26. **D.**

(3)

City of God.

"And I heard a great voice from the throne, saying : Behold the tabernacle of God with men, and he will dwell with them. And they shall be his people: and God himself with them shall be their God."

Apocalypse xxi : 3. **D.**

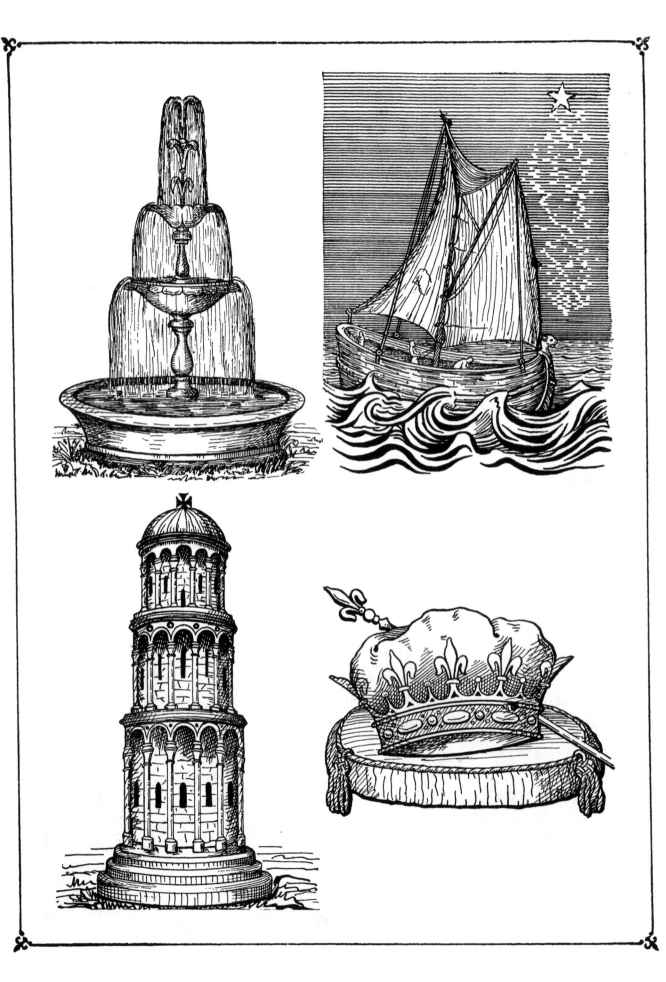

Plate *LVI* SYMBOLS AND EMBLEMS

Litany of the Blessed Virgin
(Continued.)

(1)

Fountain.

" The fountain of gardens : the well of living waters, which run with a strong stream from Libanus."

Canticles iv : 15. D.

(2)

Star of the Sea.

(3)

Tower of Ivory.

"Thy neck is a tower of ivory."

Canticles vii : 4. D.

(4)

Queen of Heaven.

See Apocalypse xii : 1. D.

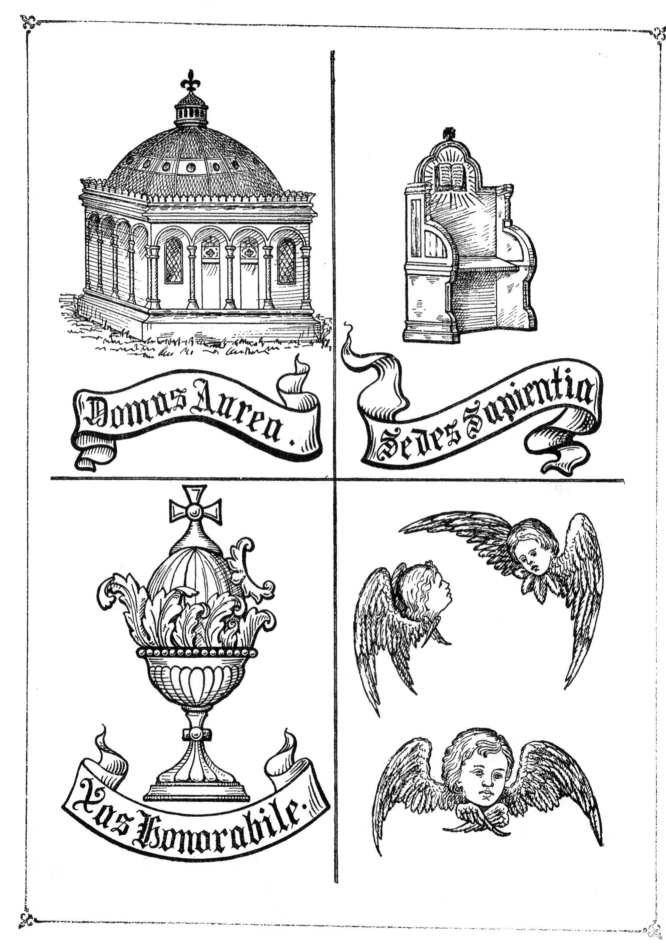

Domus Aurea.

Sedes Sapientia

Vas Honorabile.

Plate LVII SYMBOLS AND EMBLEMS

Litany of the Blessed Virgin
(Continued.)

(I)

House of Gold.

(2)

Seat of Wisdom.

(3)

Vessel of Honor.

The later idea of dispensing with the use of diphthongs has been adopted in the writing of these Latin titles.

(4)

Cherubs are so frequently used in connection with this subject that three are given here.

———————

Ark of the Covenant is also an emblem of the Litany. (See Plate xix.)

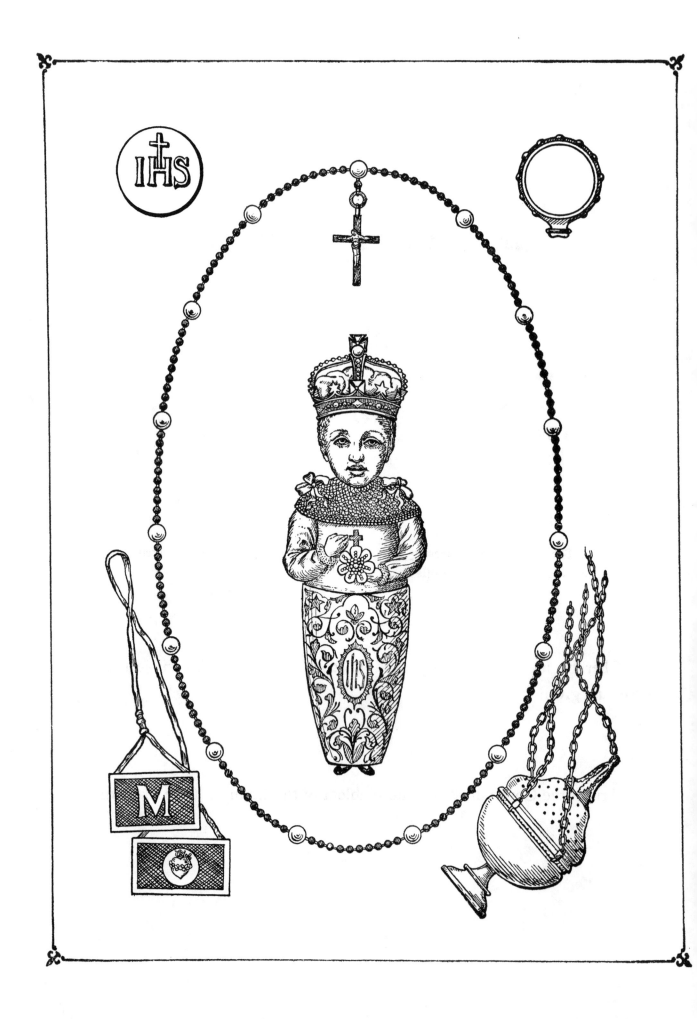

Plate LVIII SYMBOLS AND EMBLEMS

Bambino (Child)

In this connection, the Christ Child.

A figure of the Child Jesus, represented in the manger. It is exposed in the churches from Christmas to Epiphany.

St. Francis of Assisi was the originator, in the early part of the 13th century.
It is usually highly decorated, and sometimes adorned with jewels.

Rosary

A complete rosary has fifteen large, and one hundred and fifty small beads. The former represent the " Pater Nosters," the latter the "Ave Marias," in imitation of the one hundred and fifty Psalms, recited by the Clergy.

The rosary as used now was instituted by St. Dominic, though the beads were used for this purpose before his time.
The festival of the rosary was instituted by Gregory XIII., after the battle of Lepanto, A.D. 1571.

Wafer

A thin, circular disk of unleavened bread, used in the celebration of the Eucharist.

The wafer is usually stamped with the form of the cross, crucifix, Agnus Dei, or the sacred monogram.
The wafer takes its shape from the form of the bread used in the church, by the Jews, in the apostolic days.

Ring

Rosary Ring.

Formerly much used throughout Europe.

Scapular

Two small pieces of cloth connected by strings, and worn over the shoulders.

A token of devotion in honor of the Virgin.

The originator of the scapular was St. Benedict.

Censers

The censer is a vessel in which incense is burned before the altar. It is swung in the hand by chains. (See Num. iv: 14.)

They are used in the Roman Catholic, the Greek, and in some Anglican churches.

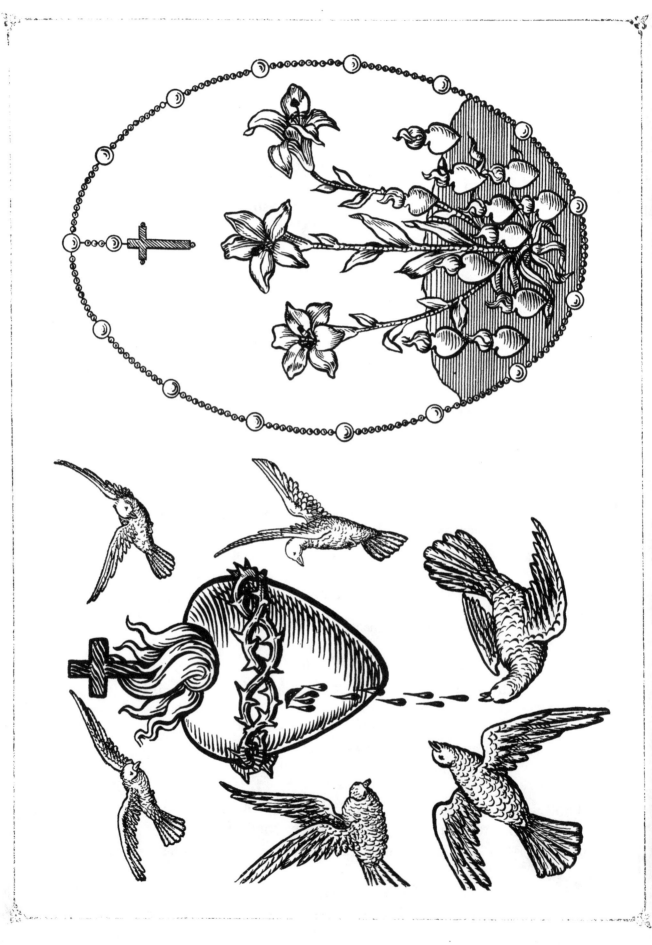

Plate LIX SYMBOLS AND EMBLEMS

(I)

Riches of the Sacred Heart.

"As the hart panteth after the fountains of water; so my soul panteth after thee, O God."

Psalms xli : 2. D.

Feast of the most Sacred Heart of Jesus.

Christ appeared to Saint Margaret Mary Alacoque, and promised her that His heart should be dilated to impart abundantly the influence of its divine love to those who shall render this honor, or cause it to be rendered to His heart.

Father de la Colombiere, S.J., was the first disciple to consecrate himself to the heart of Jesus. This consecration took place June 21st, 1675, the Friday after the octave of Corpus Christi.

(2)

Emblems of the Order of the Rosary, consisting of the lily (emblem of the Blessed Virgin), eleven flaming hearts and the rosary.

Sometimes this emblem is made with a smaller six-pointed star (Creator's) surrounded by a larger six-pointed star, the points of the larger star going below the centre lily, and above the base of the cross at the top, the space being greater between the two points than in the illustration.

Souls in keeping of the Blessed Virgin.

Some say that as the number of hearts shown are always eleven, they are the hearts of the disciples. But I can find no authority for this reading of the emblem.

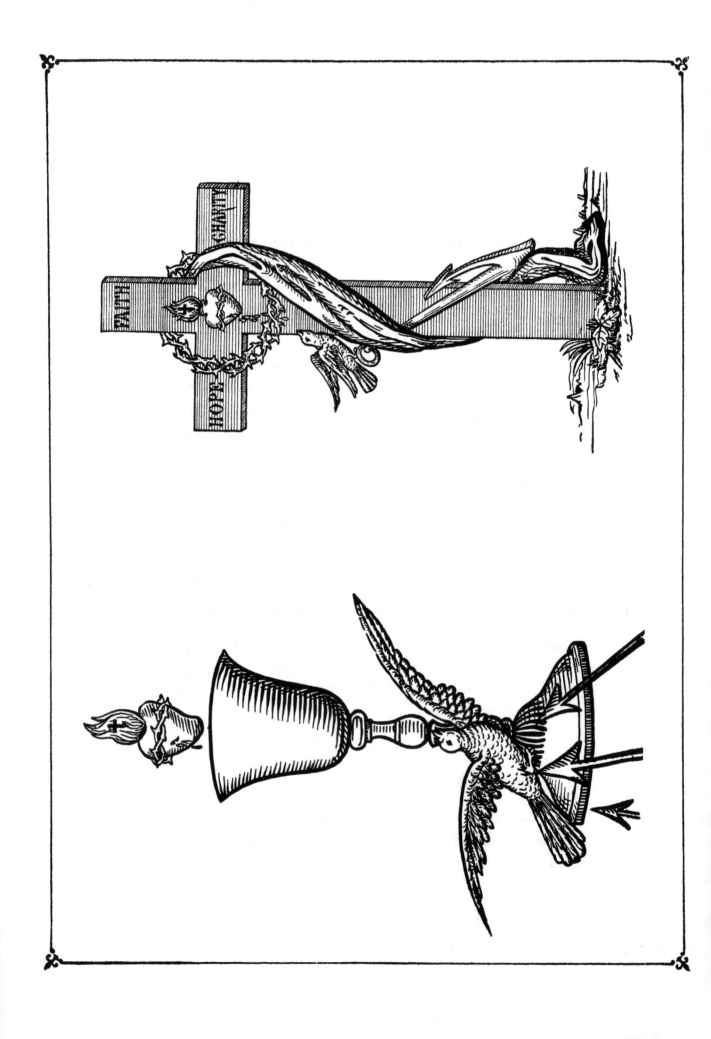

Plate LX SYMBOLS AND EMBLEM

(I)

The Persecuted Soul.

Even at the feet of Jesus the faithful soul finds trials.

"And all that will live godly in Christ Jesus, shall suffer persecution."

2 Timothy iii : 12. D.

(2)

The Treasures of the Cross.

"And now there remain faith, hope, and charity, these three: but the greatest of these is charity."

1 Corinthians xiii: 13. D.

" But God forbid that I should glory, save in the cross of our Lord Jesus Christ; by whom the world is crucified to me, and I to the world."

Galatians vi : 14. D.

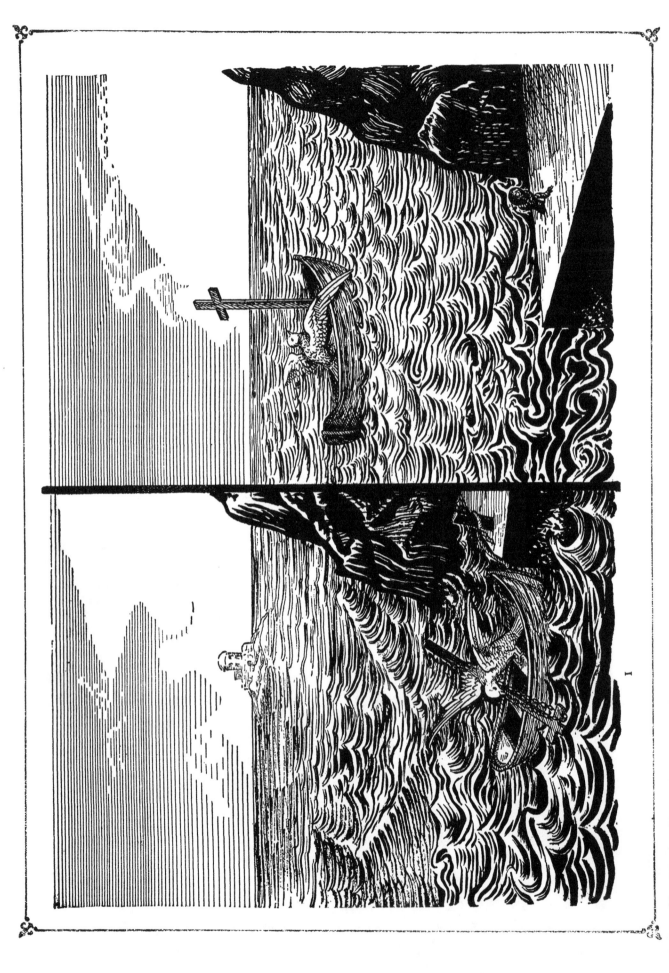

I

Plate LXI SYMBOLS AND EMBLEMS

(1)

The Boat preferred to the Cross.

The soul about to start on life's voyage is apt to prefer the boat to the cross. You cannot find a safer path than God's.

" He that feareth man, shall quickly fall : he that trusteth in the Lord, shall be set on high."

Proverbs xxix : 25. D.

(2)

Happy Crossing. The Start.

The soul has chosen the cross.

The vision of the cross which guides you shall appear in the heaven when the Lord shall come to judge the world.

"And then shall appear the sign of the Son of man in heaven : and then shall all tribes of the earth mourn : and they shall see the Son of man coming in the clouds of heaven with much power and majesty."

Matthew xxiv : 30. D.

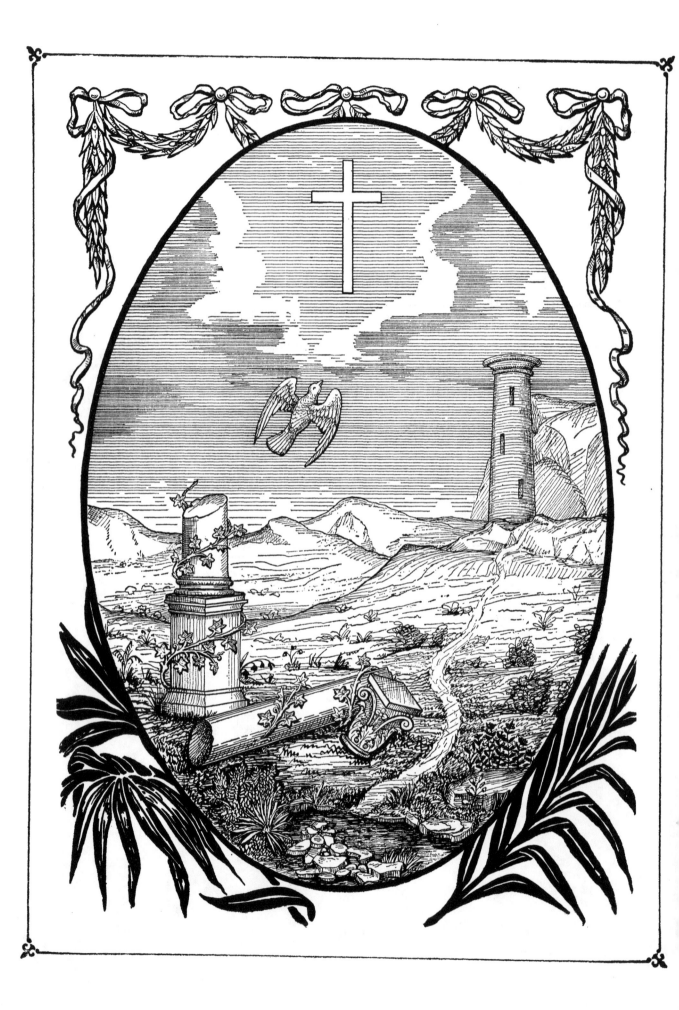

Plate *LXII*

SYMBOLS AND EMBLEMS

Release and Flight of the Soul

The broken column represents death.

The tower is the Church. The Church makes the way plain and leads to the Cross.

"To deliver their souls from death."

Psalms xxxii : 19. **D.**

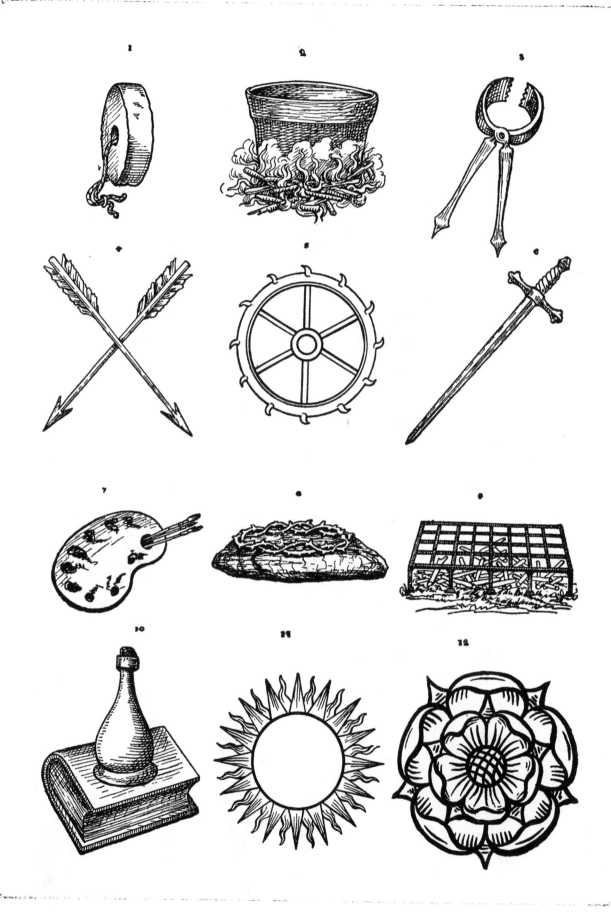

Plate LXIII SYMBOLS AND EMBLEMS

𝔄ttributes of 𝔖aints

Some saints bear more than one attribute. The attribute first mentioned is the one most frequently used.

(1) 𝔐illstone

St. Aurea.

St. Callixtus.

St. Christina, also the arrow, palm and crown.

St. Florian had the millstone tied around his neck, and then was thrown in the river. Florian has also a pitcher of water, with which he put out a conflagration.

St. Quirinus, Bishop.

St. Victor of Marseilles.

(2) 𝔠auldron

St. Cecilia, an organ, a crown of roses, a roll of music, a palm, and a cauldron of boiling water.

St. Fausta, a cauldron of boiling lead.

St. Felicitas, a cauldron of boiling oil.

St. John the Disciple was thrown into a cauldron of boiling oil, from the effects of which he was miraculously saved. The cauldron is used as one of his attributes.

St. Vitus, a cauldron of boiling oil, the palm, lion, wolf and cock.

(3) 𝔓incers

St. Agatha, also the scourge, a salver with the breast on it, and the palm ; sometimes she has the shears beside her.

St. Apollonia has the pincers with her tooth in them, also the palm and fire.

St. Dunstan has red hot pincers.

St. Lucy has her eyes on a dish, with or without the awl, also the pincers and palm.

St. Macra.

St. Pelagius, red hot pincers ; a javelin is thrust in his shoulder.

(4) 𝔄rrows

St. Sebastian, also has the palm.

St. Teresa, book, pen and arrow.

St. Ursula, the crown of the princess, staff of the pilgrim, a white banner with a red cross on it, an arrow, and a broad mantle with maidens under it, and a dove.

(5) 𝔚heel

St. Catherine of Alexandria has the wheel, which is usually broken (the wheel was broken by divine interposition), also the crown of royalty, the palm and book.

St. Euphemia.

St. Quintin, also an iron spit.

Attributes of Saints

(Continued.)

(6) Sword

St. Adrian, also an anvil. " The anvil is an emblem of death."

St. Agnes has a lamb, sword and fire.

St. Alban, also a fountain springing up at his feet, his cloak is also spread at his feet.

St. Angelus has his sword thrust in him, also has a book and palm, with three crowns.

St. Barbara has a tower with three windows, the chalice and wafer, a book, palm, also the sword. She was beheaded by her father.

St. Celsus, also palm.

St. Chrysogonus, also palm.

Sts. Cyprian and Justina of Antioch. Cyprian is represented as a Greek bishop without the mitre, bearing a palm and sword and trampling magical books under his feet. Justina holds the palm, and the unicorn (emblem of chastity) is at her feet.

St. Henri, the sword; and the world, surmounted by a cross, crown and mitre, on his head.

St. Justina of Padua, a sword transfixing her bosom.

St. Margaret, the dragon and standard, chain in her hand, also palm, and the sword at her feet.

St. Martine, a sword cutting his mantle in half, on account of his charitableness.

St. Paul has the sword; he was beheaded at Rome.

St. Susanna, also palm.

St. Thomas of Canterbury represented as a Bishop, has the sword, palm and axe.

(7) Palette

St. Luke. He is said to have painted the likeness of the Blessed Virgin.

St. Raphael, the celebrated artist.

(8) Crown of Thorns

St. Catherine of Ricci, also crucifix, scourge, and bears the stigmata.

St. Catherine of Siena, also rosary, cross entwined with lily, and bears the stigmata.

St. Louis of France, also his kingly crown and sword.

(9) Gridiron

St. Gorgon, also a palm.

St. Lawrence the Deacon, sometimes he has a dish of money, and the palm.

(10) Book and Flask

St. Walburga after her death was entombed in a rock (near Eichstadt) from which exuded a wonderful oil; it was called Walpurgis oil, and many remarkable cures were effected by its use. This oil was thought to proceed from the remains of the saint.

Attributes of Saints

(Continued.)

(11) Sun

St. Thomas Aquinas's attributes are the books or book, pen or inkhorn, the sacramental cup (on account of his having composed the office of the Blessed Sacrament), and on his breast he bears a sun, which sometimes has an eye within it.

(When a saint bears a sun on the breast it symbolizes the light of wisdom.)

(12) Rose

A conventional treatment of the rose, much used in church decorations. In England it is called the Tudor rose.

The names and attributes of some other saints are given in the following list:

Albertus Magnus (instructor of Thomas Aquinas), book and pen.

St. Aloys has the lily cross, and beads and crown at feet.

St. Alphege has his chasuble full of stones.

St. Ambrose, a knotted scourge, sometimes a bee-hive at his feet.

St. Antonius, crosier, balances, and bears the stigmata.

St. Antony, lily and crucifix.

St. Antony of Hungary has a club.

St. Augustine, represented as a bishop, has a book, a flaming heart on his breast (emblem of divine love); he bears the stigmata.

St. Balbino, chains in her hand or near her.

St. Bavon has a falcon.

St. Benedict has a staff and water-bottle, crucifix, rosary, and a shell on his right shoulder.

St. Benedict, founder of the Benedictine Order, open book, chalice, wafer, roll, crow at feet.

St. Beno, a fish with a key in its mouth.

St. Bernard of Clairvaux, demon fettered behind him, three mitres on his book, a bee-hive (emblem of eloquence).

St. Bibiana, scourge and dagger.

St. Blaise of Sebaste, an iron wool comb.

St. Bonaventura, represented as an archbishop.

St. Brice carries red-hot coals in his hands unhurt.

St. Bridget, book and pen.

St. Charles Borromeo, represented barefooted, one hand raised in benediction, a book in the other. Sometimes in cardinal's robes, a chalice in one hand and wafer in the other.

NOTE.—Stigmata are marks upon the bodies of certain saints, representing the wounds our Lord received at His crucifixion.

Attributes of Saints

(Continued.)

St. Christopher bears the Christ Child on his back, and a bough in his hand.

St. Clara had the pyx containing the host, lily, cross, and palm.

St. Clement has an anchor.

St. Coleta has a sheep in her arms, a staff with banner on it.

Sts. Cosmos and Damian have a jar and a box of ointment.

St. Crispin has an awl and shoemaker's knife.

St. Cunibert has a dove.

St. Cuthbert has an otter and the head of St. Oswald.

St. Denis, Patron of France, has a severed head.

St. Dominick has a dog by his side, a star on or above his head, a lily in one hand, a book in the other. Founder of the Dominican Order.

St. Dorothea of Cappadocia has roses in her hand or on her head ; or a basket with three apples and three roses held by an attendant angel.

St. Elizabeth of Hungary has roses.

St. Elgins has hammer in his hand with crown on it. Bishop.

St. Eugenius has a club.

St. Francis Borgia has a skull with a crown on it.

St. Francis de Sales, represented as a bishop, with a flaming heart on his breast.

St. Francis of Assisi, founder of the Franciscans, bears the stigmata, and has a book in his hand.

St. Francis Xavier has a ship and a crucifix.

St. Genevieve of Paris has a flock of sheep, a distaff, and holds cake in her dress.

St. George, Patron Saint of England and Russia. The Dragon.

St. Gertrude, a book and pen, and has a heart on her breast.

St. Giles has a wounded hind.

St. Gregory the Great has a dove.

St. Guillielmus has a taustaff.

St. Helena has a cross, crown, a book on a stand, and four nails on a cushion beside her.

St. Hilarius has a closed book, a dragon at his feet. He is represented as a bishop.

St. Hubert has a stag with a crucifix between its horns, also a horn and a lance.

St. Hugh, Bishop of Lincoln, has a swan.

St. Ignatius Loyola (founder of the order of the Jesuits), has a book and pen, and the seal of the order (I. H. S.) above his head.

St. Jean of Nepomuk has a palm and cross on one hand, seven stars in nimbus, a padlock (denoting silence) on his mouth or in his hand, also a bridge in his hand.

St. Jeanne de Toulouse has a lily and crucifix, and a globe surmounted by a cross under one foot.

St. Jerome has a book and a lion.

St. John Berchmans has a book, a rosary in hand and seal of Jesuits.

St. John of the Cross has an eagle at his feet, a cross in one hand.

St. Joannes Coloniensis has a palm and a monstrance.

St. Julian Hospitator has a stag.

Attributes of Saints

(Continued.)

St. Lambert, represented as a bishop, has a book in his hand; also has a palm and javelin.

St. Leonard has a chain; sometimes bears a crosier.

St. Ludgerus has a church, an eagle at his feet, and bears the stigmata.

St. Margaret of Cortona has a dog. (The dog is an emblem of fidelity.)

St. Mathilde has a church and a crucifix.

St. Maurus has a book or a censer.

St. Monica, mother of Saint Augustine.

St. Neot has a pilgrim's staff and wallet.

St. Nicholas, represented as a bishop, three balls on the ground near him.

St. Norbert has a cup with a spider over it; he is represented as an archbishop.

St. Ottilia, a palm or crosier, two eyes on a book.

St. Patrick, Patron Saint of Ireland, represented with a staff and wallet, and standard with cross. He is usually represented by the seashore expelling snakes.

St. Petronius has a model of Bologna in his hand.

St. Petrus de Verona, book and palm, a dagger thrust in his shoulder.

St. Pharailde, a goose and three cakes at the feet.

St. Phocas of Sinope has a spade.

St. Pius Quintus, a cross and three crowns, a rosary, and bears the stigmata.

St. Placides has the palm.

Sts. Praxedes and Pudentiana have a cup and sponge.

St. Prisca has a palm and a lion at her feet.

St. Procopius, a wounded hind.

St. Proculux, an axe.

St. Raymond has his lips bored through with a red-hot iron and fastened with a padlock.

St. Raymond de Pennaforte, a book and key, also a mantle on which he floats out to sea.

St. Reparata has the standard or banner (symbol of victory), crown and palm.

St. Roch has a dog and staff.

St. Romoldus, represented as a bishop.

St. Sabina has a palm.

St. Salomea, a lily, crucifix, crown, and the earth surmounted by the cross on a table at her side.

St. Stanislas Koatka, a lily.

St. Stanislaus, represented as a bishop, with a book in hand, beggar at his feet.

St. Thecla has the palm, and beasts around her.

St. Tonatiane, represented as a bishop, with seven lights.

St. Victor, represented as a Roman soldier.

St. Vincent, a crow or raven. (Vincent the Deacon.)

St. Vincent de Paul, represented as a priest, with an infant in his arms.

St. Vincent Ferrer, represented with wings, has an open book in his hand, also a crucifix.

St. Wilhelm of Aquitaine, a skull, cross, armor at his side, water bottle and cakes.

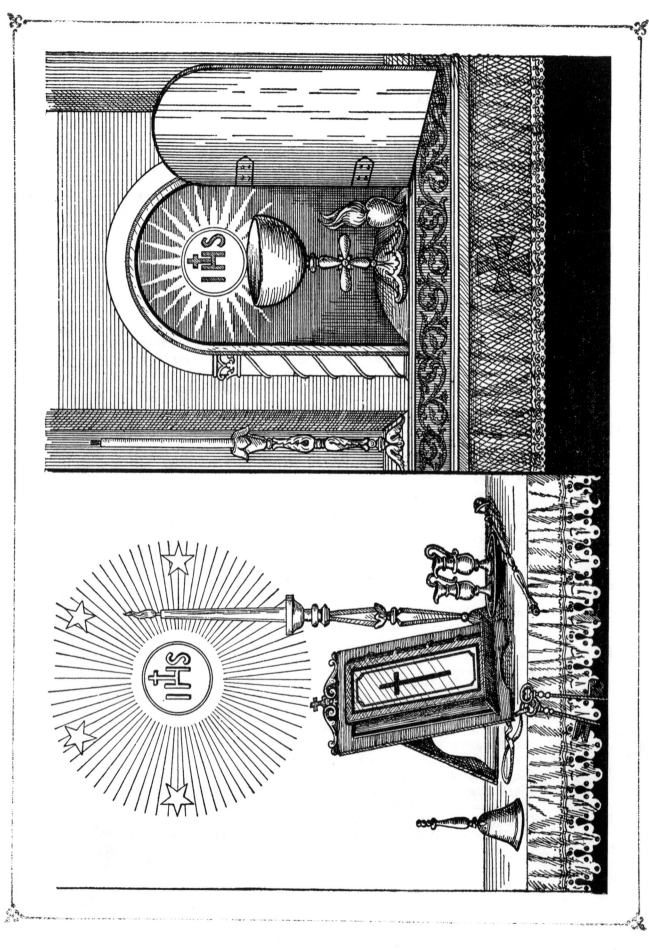

Plate *LXIV* SYMBOLS AND EMBLEMS

(1)

This emblem is called God-Bidden, God-Living (called and living to God.) It represents the most sacred vessels of the church used only by the priest.

(2)

Attributes of those in Minor Orders.

The holy vessels used by those in minor orders. As they are occasionally used in church decoration, they are properly shown here.

Plate LXV SYMBOLS AND EMBLEMS

Monograms

(1)

A, Alpha ; *Ω*, Omega.

The first and last letters of the Greek alphabet. Alpha (beginning), Omega (end) ; Christ is all in all, the beginning and the end.

> "I am Alpha and Omega, the beginning and the end, the first and the last."
>
> *Revelation xxii : 13.*

> "I am Alpha and Omega, the beginning and the ending, saith the Lord."
>
> *Revelation i : 8.*

(2)

X. P. Earliest known form of monogram. It is sometimes wrongly called the Labarum.

> The labarum is the standard which bears the chrisma, the *X. P.*
> The first two letters of the Greek word for Christ (*ΧΡΙΣΤΟΣ*) are Chi, Rho. The monogram is found on the tombs of the Christian martyrs of the second century. Sometimes the *X* is turned into R, implying Rex, the Kingship of Christ.

(3)

I. H. S. or I. H. C.

> No symbol or emblem has caused so much discussion as this monogram. It is contended that it was originally *I. H. Σ.*, the first two and last letters of the Greek word *IHΣΟΥΣ* (Jesus), but its origin was lost sight of, and the Latin letter S substituted for the *Σ*, and a Latin word for each letter. I* or J, Jesus ; H, Hominum ; S, Salvator ;—" Jesus the Saviour of man." Also, " In Hoc Salus " and " In Hoc Signo," meaning, " In this (cross) is salvation," " By this sign " (conquer). It was usual to put the mark of abbreviation over the letters I. H. S. This mark was altered into a cross, and it became the I. H. S. as it is now used in the Roman Church.

(4)

I. H. S.

(5)

I. H. C. Another form of I. H. S.

> The C and S are very similar in the Greek, the C being used by some authorities in preference to the S, as they claim it to be nearer the original.

* Formerly there was no J in the Latin language, hence the use of the letter I.

Plate LXVI SYMBOLS AND EMBLEMS

Monograms

(Continued)

(1)

A. Alpha separate with cross.

(2)

Ω. Omega separate with cross.

(3)

Alpha and Omega combined with cross.

(4 and 5)

Two other forms of the I. H. S.

Plate LXVII

SYMBOLS AND EMBLEMS

Monograms

(*Continued.*)

(1)

Alpha and Omega.

(2)

I. H. S. (Previously explained opposite Plate lxv.)

(3)

Chi Rho and I. H. S. combined.

(4)

I. H. C. (Previously explained opposite Plate lxv.)

(5)

Alpha and Omega combined.

Monograms

(*Continued.*)

(1)

A. M., Ave Maria. (Hail Mary.)

A devotional prayer.

(2)

Maria. The whole name is formed by the monogram.

(3)

Ornamental A. M. (Ave Maria.)

(4)

Fleur-de-Lis.

> A conventional treatment of the lily. Emblem of the Virgin; also of purity, chastity and virtue.

(5)

Monogram. Jesus and Maria.

(6)

This form of the I. H. S. was adopted by the Jesuits as the badge of their order.

1 2

IHΣ XPΣ

3 4

5 6

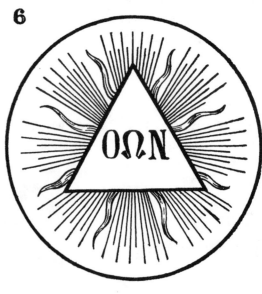

Plate LXIX SYMBOLS AND EMBLEMS

Monograms

(Continued.)

(1)

I. H. Σ. First two and last letters in the Greek word for Jesus.

(2)

X. P. Σ. First two and last letters in the Greek word for Christ.

(3)

The *I* (Iota), for Jesus, and *X* (Chi), for Christ, surrounded by the circle of eternity or perfection.

(4)

Cross and monogram of Jesus Christ combined.

(5)

Two capital Gammas, crossed; said to be the signum or sign of faith in the Crucified, and is called a fylfot or swastika.

(6)

Emblem of the Trinity, with the Greek letters meaning, "I AM THAT I AM " in the centre; enclosed within the circle of perfection, without beginning and without end.

 Radiating from the triangle are the Greek and St. Andrew crosses.
 Between the spaces are flaming tongues representing the activity of the love of the Spirit.

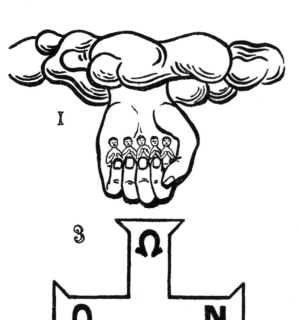

1

2

3

Ω
O · N

4

A, M, Ω.

5

IC. XC.

6

MP OY

7

8

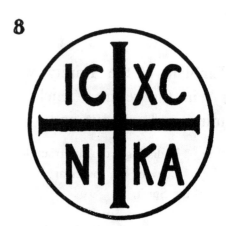

Plate LXX SYMBOLS AND EMBLEMS

Monograms

(*Continued.*)

(1)

The souls of the redeemed in the hand of the Almighty.

> " In whose hand is the soul of every living thing and the breath of all mankind."
>
> *Job 12 : 10.*

(2)

Greek form of Benediction.

> In the Greek form of benediction the forefinger is extended to resemble the letter I, while the middle finger is bent in a C-like form. The thumb and third finger are crossed to make an X, and the little finger is bent into a C again, so that we get I C, X C, the initial and final letters of the Greek name for Jesus Christ.

(3)

0. Omicron. *Ω.* Omega. *N.* Nu.

> " I am," or " He who is."

(4)

A. Alpha. *M.* Mu. *Ω.* Omega.

> The commencement, middle and end of the Greek alphabet.
> Christ comprises in himself the past, present and future. Christ is all in all.

(5)

I. C. Jesus. X. C. Christ.

(6)

MP OY. The Mother of God.

(7)

X. P. N. Our Lord Jesus Christ.

(8)

Combination of the Cross and IC. XC. NI. KA.

> Jesus Christ the Conqueror. Surrounded by the circle, it means Eternal and Perfect Conqueror.

Plate LXXI SYMBOLS AND EMBLEMS

(1)

Lamp; emblem of light and knowledge. It is also used as an emblem of religious fervor and zeal.

"Let your light so shine before men, that they may see your good works, and glorify your Father which is in heaven."

Matthew v : 16.

The lamps of the early Christians were found in abundance in the Catacombs.

(2)

Open Book; signifies perfect intelligence.

"Thy word is a lamp unto my feet and a light unto my path."

Psalms cxix : 105.

The scroll or roll is used as an emblem of prophecy and partial light.

(3)

The Word and the Light.

When space is an object, the bible and lamp are often used together.

(4)

Cross and Bible.

"Take up his cross and follow me."

Mark viii : 34.

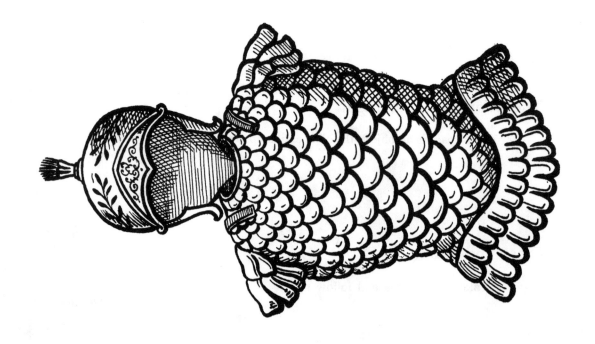

Plate *LXXII* SYMBOLS AND EMBLEMS

Armour of God

" Wherefore take unto you the whole armour of God, that ye may be able to withstand in the evil day, and, having done all, to stand.

" Stand, therefore, having your loins girt about with truth, and having on the breastplate of righteousness;

"And your feet shod with the preparation of the gospel of peace;

" Above all, taking the shield of faith, wherewith ye shall be able to quench all the fiery darts of the wicked.

"And take the helmet of salvation, and the sword of the Spirit, which is the word of God."

Ephesians vi: 13-17.

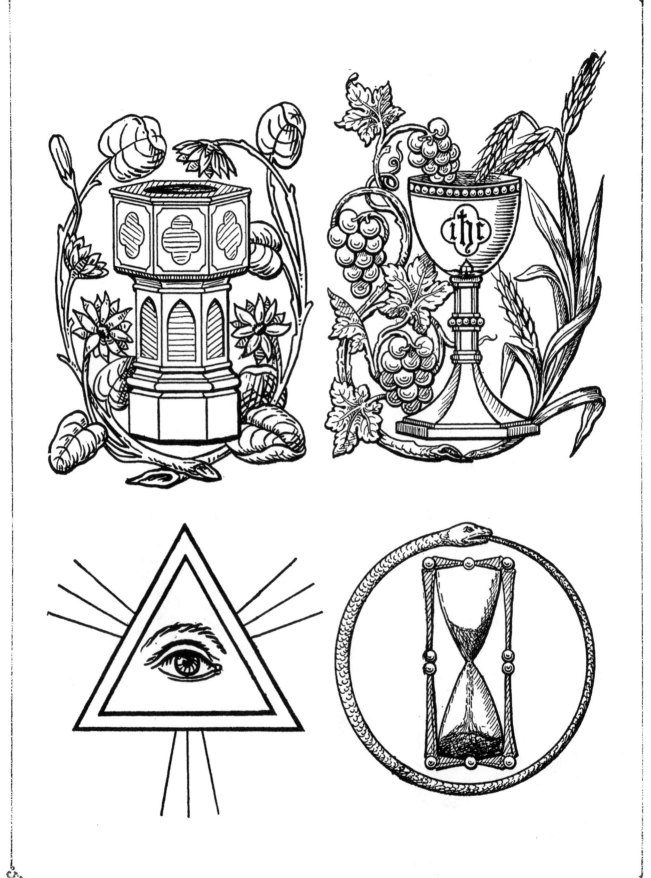

Plate *LXXIII* SYMBOLS AND EMBLEMS

𝕰𝖒𝖇𝖑𝖊𝖒𝖘 𝖔𝖋 𝕭𝖆𝖕𝖙𝖎𝖘𝖒 𝖆𝖓𝖉 𝕽𝖊𝖌𝖊𝖓𝖊𝖗𝖆𝖙𝖎𝖔𝖓

(I)

Font and Water Lily.

> " Then Peter said unto them, Repent, and be baptized every one of you in the name of Jesus Christ, for the remission of sins." *Acts ii : 38.*

𝕰𝖒𝖇𝖑𝖊𝖒𝖘 𝖔𝖋 𝕮𝖔𝖒𝖒𝖚𝖓𝖎𝖔𝖓

(2)

Chalice.

> " For as often as ye eat this bread, and drink this cup, ye do show the **Lord's** death till he come." *1 Corinthians xi : 26.*

Grape-Vine. If used in connection with the chalice, means the blood of Christ.

> "After the same manner also he took the cup, when he had supped, saying, This cup is the new testament in my blood." *1 Corinthians xi : 25.*

If used alone, it is emblematic of Christ.

> " I am the true vine." *John xv : 1.*

Wheat. If used with the chalice, means the body of Christ.

> "And when he had given thanks, he brake it, and said, Take, eat ; this is my body." *1 Corinthians xi : 14.*

✠

(3)

All-Seeing Eye. " The omnipresence of the Triune God."

> " The eyes of the Lord are in every place, beholding the evil and the good."
> *Proverbs xv : 3.*

(4)

Hour Glass. " Time."

> " So teach us to number our days." *Psalms xc : 12.*

Snake with its tail in its mouth. A very ancient emblem of Eternity. The snake is an emblem of Wisdom.

Plate LXXIV SYMBOLS AND EMBLEMS

(I)

Wheat. Besides being emblematic of the body of Christ (See Matt. xxvi : 26), it is also an emblem of his Church, and of a finished life through him.

"Let both grow together until the harvest : and in the time of harvest I will say to the reapers, Gather ye together first the tares, and bind them in bundles to burn them ; but gather the wheat into my barn."

Matthew xiii : 30.

(2)

Chalice and Paten. Emblems of the Lord's Supper.

"And as they did eat, Jesus took bread, and blessed, and brake it, and gave to them, and said, Take, eat ; this is my body.

"And he took the cup ; and when he had given thanks, he gave it to them : and they all drank of it."

Mark xiv : 22, 23.

(3)

Cross and Crown.

"Then said Jesus unto his disciples, If any man will come after me, let him deny himself, and take up his cross, and follow me."

Matthew xvi : 24.

"Henceforth there is laid up for me a crown of righteousness."

2 Timothy iv : 8.

(4)

Anchor, Cross and Crown.

"Which hope we have as an anchor of the soul, both sure and steadfast."

Hebrews vi : 19.

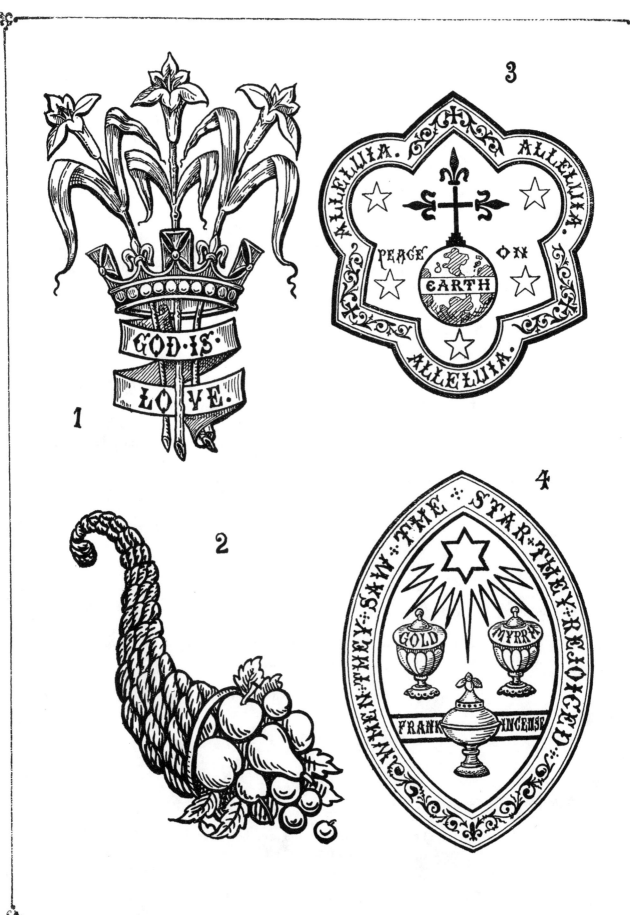

Plate LXXV SYMBOLS AND EMBLEMS

(I)

A conventional arrangement of the Lily, Crown and Text.
Lily—purity.
Crown—victory or reward.

(2)

Cornucopia ; emblematic of offering.

> "And the feast of harvest, the first-fruits of thy labours which thou hast sown
> in thy field ; and the feast of ingathering, which is in the end of the year, when
> thou hast gathered in thy labours out of the field."
>
> *Exodus xxiii : 16.*

(3)

Nativity emblem. Containing the world, surmounted by the Cross, with the steps Faith, Hope and Charity. (Meaning Salvation for all.)

> The ends of the arms of the cross are finished with the fleur de lis (purity),
> or may be said to refer to the Blessed Mother. It also contains the Christmas
> morning text, " Peace on earth; " the stars, and the angels' song, "Alleluia."
> The outer form is emblematic of the Trinity.

(4)

Emblem in connection with the Nativity. Contains the quotation from Matthew: "When they saw the Star, they rejoiced with exceeding great joy."
Star (Creator's) and the offering of the Wise Men.

> "And when they had opened their treasures, they presented unto him gifts;
> gold, and frankincense, and myrrh."
>
> *Matthew ii · 11.*

> The outer form is the fish form symbol, which was so much used on the
> tombs of the Christians in the Catacombs. It is called Vesica piscis.

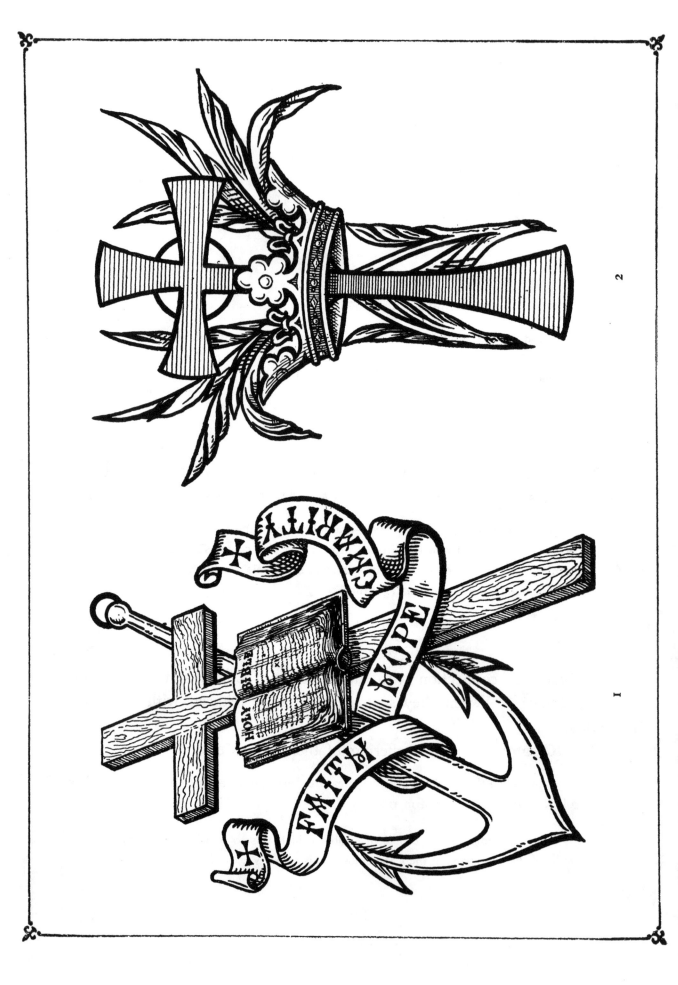

Plate *LXXVI* SYMBOLS AND EMBLEMS

(1)

The Cross symbolizes Faith ; the Anchor, Hope ; the Bible, Charity.

"And now abideth faith, hope, charity, these three ; but the greatest of these is charity."

1 Corinthians xiii : 13.

(2)

The Cross here symbolizes Trials ; the Palms, Victory ; the Crown, Reward.

" Blessed is the man that endureth temptation : for when he is tried, he shall receive the crown of life, which the Lord hath promised to them that love him."

James i : 12.

The form of cross used in this emblem is called the cross of Iona. It is the earliest known form of the cross used in Great Britain, and is still in general use there.

(Any form of the cross can be substituted for this one.)

Plate LXXVII SYMBOLS AND EMBLEMS

(I)

Sword and Balances

Two meanings can be taken from this emblem.
The first, Justice and Judgment.

> "Just balances, just weights, a just ephah, and a just hin, shall ye have: I am the Lord your God."
>
> *Leviticus xix : 36.*

> "If I whet my glittering sword, and mine hand take hold on judgment, I will render vengeance to mine enemies, and will reward them that hate me."
>
> *Deuteronomy xxxii : 41.*

The second, Sword of the Spirit and Truth.

> "The sword of the Spirit, which is the word of God."
>
> *Ephesians vi : 17.*

> "A false balance is abomination to the Lord: but a just weight is his delight."
>
> *Proverbs xi : 1.*

(2)

Flight of Time and Certainty of Death

The Hour Glass symbolizes Time ; the Scythe, Death.

> "Watch therefore, for ye know neither the day nor the hour wherein the Son of man cometh."
>
> *Matthew xxv : 13.*

> "Remember how short my time is: wherefore hast thou made all men in vain?
> "What man is he that liveth, and shall not see death ?"
>
> *Psalms lxxxix : 47, 48.*

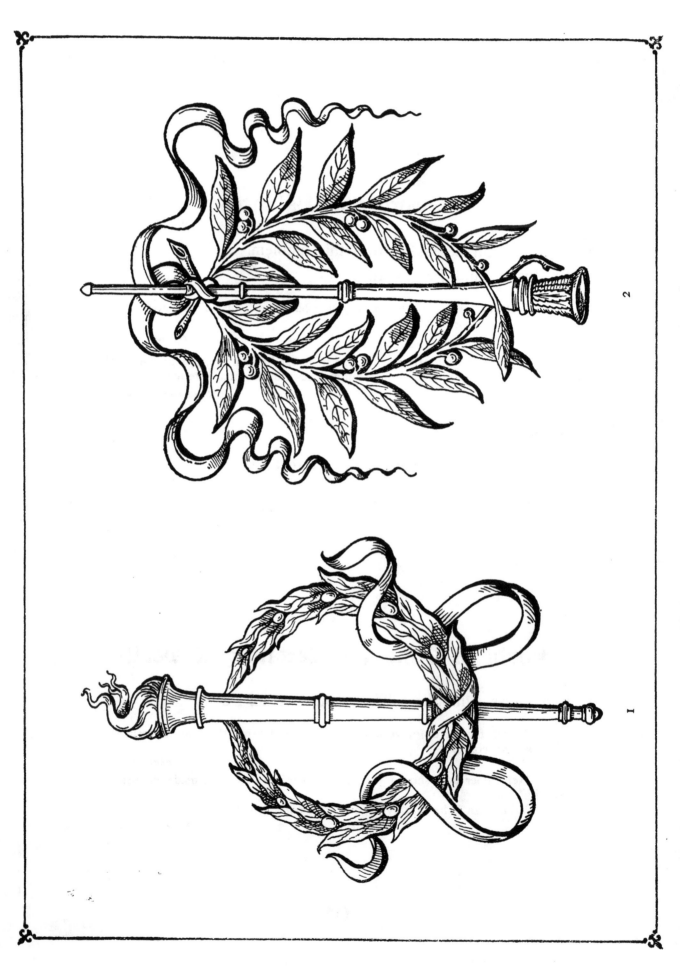

2

1

Plate LXXVIII SYMBOLS AND EMBLEMS

Torches and Wreaths

(1)

Life and Peace.

The erect burning torch is emblematic of life; the olive, of peace.

(2)

Death and Victory.

The inverted flameless torch is emblematic of death, and the laurel, of victory.

Very many of the early converts to Christianity were from among the Heathens and Pagans. Their early training influenced their ideas after conversion. They were familiar with many of the emblems of the Greeks, and used them with new ideas in their religion. These emblems are from the early Greeks.

Life and Peace, Death and Victory, through Jesus Christ.

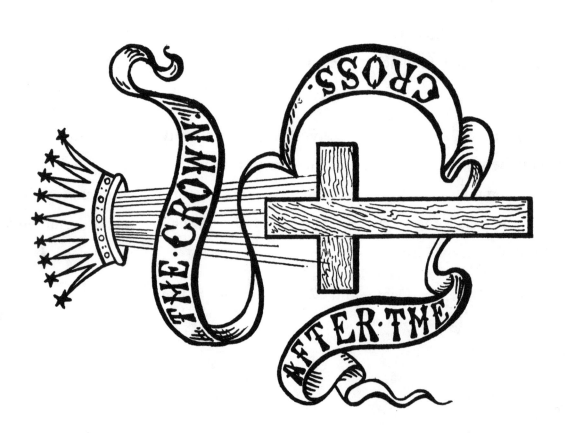

Plate LXXIX SYMBOLS AND EMBLEMS

(I)

Crown. Emblematic of reward.

"And when the chief Shepherd shall appear, ye shall receive a crown of glory that fadeth not away."

1 Peter v : 4.

In this connection the cross signifies trials and tribulations here ; the crown, reward hereafter.

(2)

Cut Flowers. Emblematic of death.

"As for man, his days are as grass ; as a flower of the field, so he flourisheth.

" For the wind passeth over it, and it is gone ; and the place thereof shall know it no more."

Psalms ciii : 15, 16.

" They are like grass which groweth up.

" In the morning it flourisheth, and groweth up ; in the evening it is cut down, and withereth."

Psalms xc : 5, 6.

(1)

Bee=Hive

The bee and ant are emblematic of work and labor.

Around the bee-hive is heard the buzz of the busy bee. Hence the bee-hive is used as an emblem of eloquence, and sometimes, of industry.

(2)

Balances

The honor, glory and riches of this world are as nothing, when weighed in the balance, against the Cross of Christ.

" Lay not up to yourselves treasures on earth: where the rust, and moth consume, and where thieves break through and steal.

" But lay up to yourselves treasures in heaven: where neither the rust nor moth doth consume, and where thieves do not break through, nor steal."

Matthew vi : 19, 20. D.

"And Jesus looking on him, loved him, and said to him: One thing is wanting unto thee: go, sell whatsoever thou hast, and give to the poor, and thou shalt have treasure in heaven; and come, follow me."

Mark x: 21.

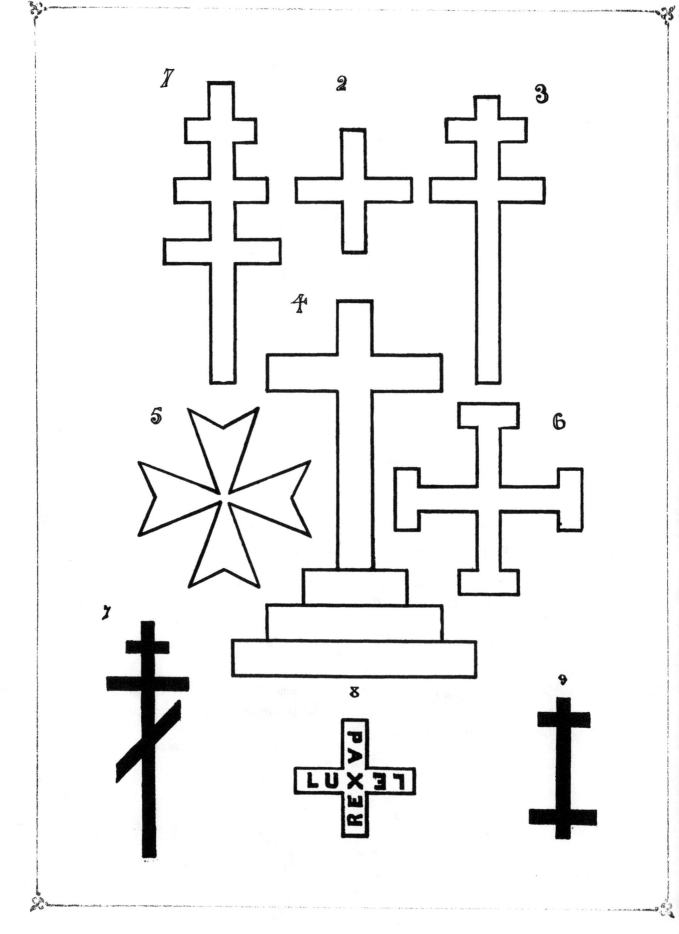

Plate LXXXI SYMBOLS AND EMBLEMS

Crosses

The cross is pre-eminently the symbol of Christianity.

(1)

Papal.

(2)

Greek, also St. George's and St. Patrick's; when used for St. Patrick the cross is red.

(3)

Patriarchal.

(4)

Calvary. The three steps represent Faith, Hope and Charity.

(5)

Maltese. The points symbolize the eight beatitudes.

(6)

Jerusalem. The Greek cross with an arm on the end of each arm, to represent the displacement of the Old Testament by the Cross.
Also known as the Teutonic cross.

(7)

The Slavonic Cross. St. Andrew was the first missionary to the Slavs, and the first to interpret the Bible in their language. Hence their crosses generally bear one-half of the St. Andrew cross.

(8)

A lettered Greek cross.
 Rex,—King. Lex,—Law. Pax,—Peace. Lux,—Light.

(9)

Cross of Lorraine.

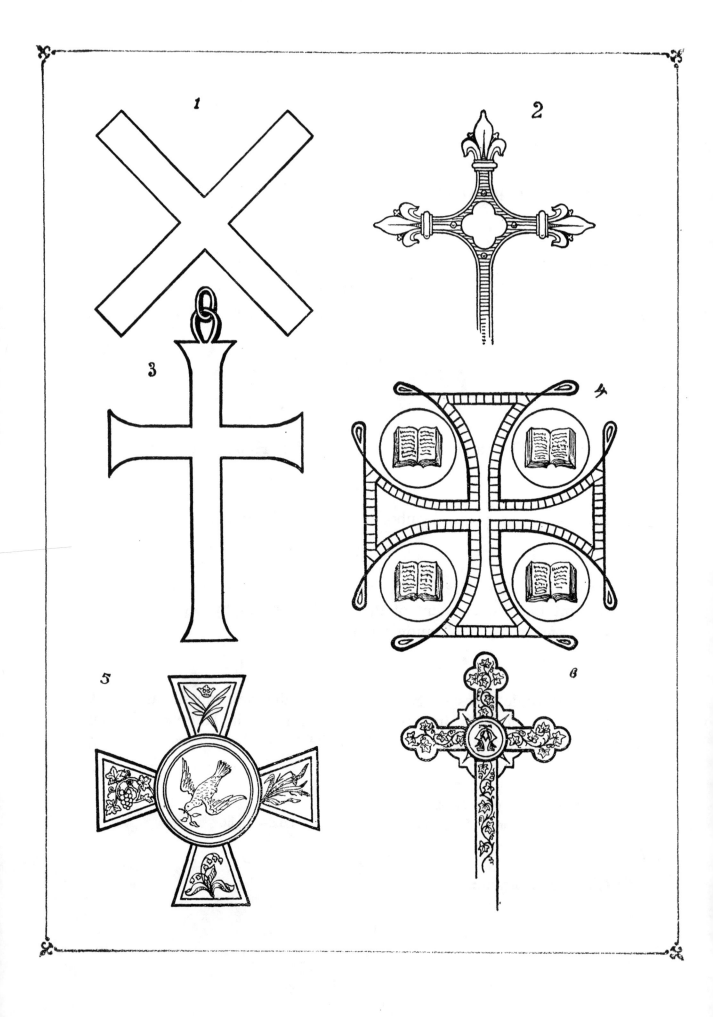

Plate *LXXXII* SYMBOLS AND EMBLEMS

Crosses

(*Continued.*)

(I)

Cross of St. Andrew, known as the cross of humility.

(2)

Decorative Cross, with the Fleur-de-Lis.

(3)

Pectoral Cross.

(4)

Cross quartered with the four gospels, found in the catacombs of the early ages.

This is the first style of representing the evangelists.

(5 and 6)

Ornamental Crosses.

Plate LXXXIII　　　　　　　　　　SYMBOLS AND EMBLEMS

Latin Cross

Embellished with the Passion Flower.　The cross can be ornamented in a number of ways, according to the taste of the artist.

Harp.　(Much used.)

"Praise the Lord with harp: sing unto him with the psaltery and an instrument of ten strings."

Psalms xxxiii: 2.

Lyre.　(Also frequently used).

Enclosing both musical instruments is a conventional treatment of the morning glory.

The morning glory is emblematic of the Resurrection.

NOTE.—When using conventional foliage for church decoration, keep, if possible, the leaves in clusters of three, as much on account of its meaning as its architectural correctness.

Plate *LXXXIV*

SYMBOLS AND EMBLEMS

Celtic Cross

The celebrated Aberlemno Cross, formed of a single slab seven feet high.

(From Owen Jones's " Grammar of Ornament.")

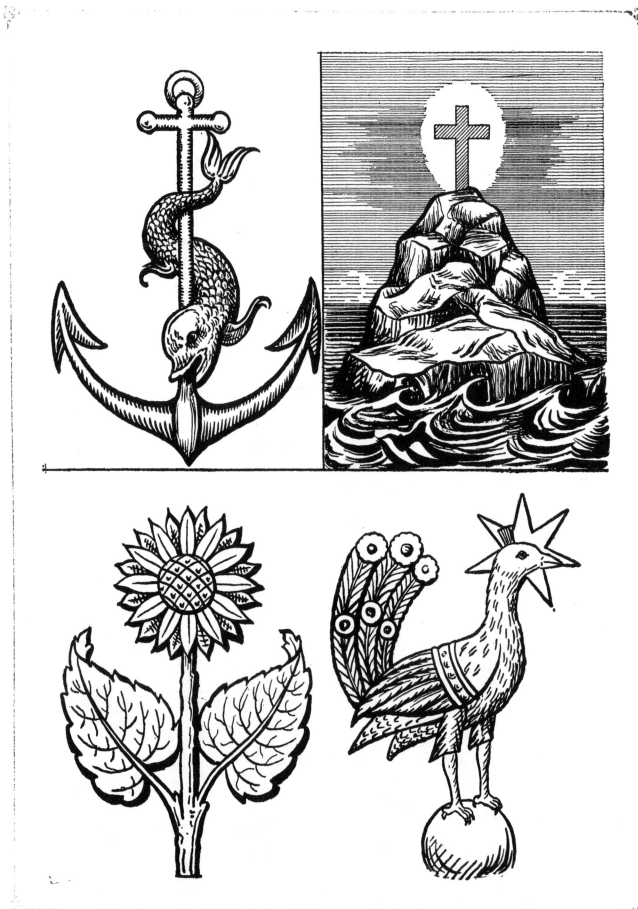

Plate LXXXV SYMBOLS AND EMBLEMS

(1)

The Anchor is an emblem of hope.

The Fish is an emblem of Christ and Baptism.

The Anchor and Fish together, emblematic of hope in Christ.

(2)

Cross (Church) on the Rock.

> " Upon this rock I will build my church ; and the gates of hell shall not prevail against it."
>
> *Matthew xvi : 18.*

(3)

The Sunflower.

Emblem of the Sun or source of light ; occasionally it is placed in the outer circle of the nimbus.

It is frequently used in church decoration.

(4)

The Peacock.

The peacock is seldom used now ; it is supposed now to represent pomp and vanity, but in the early church it was used as an emblem of the Resurrection, on account of its losing its beautiful feathers and restoring them yearly, and its flesh was said to be incorruptible. It was used as an emblem of the glorified spirit. The peacock is frequently represented without nimbus, and not standing on a globe.

Plate LXXXVI SYMBOLS AND EMBLEMS

Geometrical Forms

(1)

Triangle—Trinity and Equality. When other than the equilateral form is used it then signifies "Jehovah, I am that I am," and is said to express three attributes of the Deity—TO BE, TO THINK, TO SPEAK.

(2)

Square—Earth and Life, and earthly life.

(3)

Circle—Perfection and Eternity. Without beginning or end. Triangle within circle—the Eternity of the Trinity.

(4)

Square within circle—the Eternity of life.

(5)

Five-pointed Star contains five Alphas, and is called the Star of Beauty. Once called the Symbol of Health, and held to be a talisman against witchcraft, and that it pointed out the five places the Saviour was wounded.

(6)

Six-pointed Star—the Creator.

Geometrical Forms
(Continued.)

(I)

Seven-pointed Star. Represents the seven gifts of the Holy Ghost.

Seven days of the week, seven branches to the candlestick of Moses, seven churches of Asia, seven mysterious seals, seven stars in the right hand of God, seven trumpets, seven Heavens, etc.

(2)

Eight-pointed Star. Regeneration.

(3)

Octagon. Emblematic of regeneration; for this reason very often used for the ground plan of fonts.

(4)

Nine-pointed Star. Represents the fruits of the Holy Spirit: love, joy, peace, long suffering, gentleness, goodness, faith, meekness and temperance.

(6)

Twelve-pointed Star. The Disciples.

Plate *LXXXVIII* SYMBOLS AND EMBLEMS

Emblematic Flowers

(1)

Almond.

When making the candlesticks for the Tabernacle, Moses was commanded to make the bowls like the almond.

> "Three bowls made like unto almonds, with a knop and a flower in one branch; and three bowls made like almonds in the other branch, with a knop and a flower: so in the six branches that come out of the candlestick.
>
> "And in the candlestick shall be four bowls made like unto almonds, with their knops and their flowers."
>
> *Ex. xxv: 33, 34.*

The Jews still carry branches of the almond tree to the synagogue on great festivals.

(2)

Balm of Gilead.

Solomon was given a root by the Queen of Sheba, and he carefully cultivated it in the plains of Jericho.

> It was of great value, and was one of the trophies carried by Titus to Rome.
> Mixed with oil, it constitutes the chrism of the Roman Catholic Church.

(3)

Fig ; emblematic of prosperity.

"And Judah and Israel dwelt safely, every man under his vine and under his fig-tree."

1 Kings iv : 25.

"But they shall sit every man under his vine and under his fig-tree."

Micah iv : 4.

(4)

Frankincense.

Frankincense was used for the purpose of sacrificial fumigation.

See Ex. xxx : 34 ; Lev. ii : 16.

It is called frank because of the freeness with which, when burned, it gives forth its odor. It burns for a long time, and has a steady flame. Frankincense was among the gifts offered to Jesus at his birth.

"They presented unto him gifts ; gold, and frankincense, and myrrh."

Matt. ii : 11.

(5)

Hyssop.

Very rarely used emblematically. It was used for sprinkling in the ceremony of purification.

"He took the blood of calves and of goats, with water, and scarlet wool, and hyssop, and sprinkled both the book, and all the people."

Heb. ix: 19.

"Purge me with hyssop, and I shall be clean."

Psalms li: 7.

It was on a stem of hyssop that the sponge was given to Christ on the cross at Calvary.

John xix: 29.

(6)

Lentiles.

The great use of this food during Lent by the poorer classes throughout Europe, is supposed by many to have given to the fast its present name.

It was for a dish of red lentiles that Esau sold his birthright.

"Then Jacob gave Esau bread and pottage of lentiles; and he did eat and drink, and rose up, and went his way. Thus Esau despised his birth-right."

Gen. xxv: 34.

Plate LXXXIX SYMBOLS AND EMBLEMS

Emblematic Flowers

(*Continued.*)

(1)

Myrrh. An ingredient of the holy oil. (See Exodus xxx : 23.)
It is the gum from the bark of a small thorny balsam.

A royal oblation of gold, frankincense and myrrh is still annually presented
by the Queen of England, on the feast of the Epiphany, in the Chapel Royal, in
London, this custom having been in existence certainly as early as the reign of
Edward I. (1272-1307).

(2)

Rose of Jericho, otherwise known as the resurrection rose.

(3)

Rose, mentioned in the Bible, used as an emblem of the Blessed
Virgin.

(4)

Lily of the Valley; emblematic of humility; frequently used.

(5)

Holly; emblematic of rejoicing.

Frequently used throughout the British Isles. It is much used at
Christmas for church decoration.

Plate XC SYMBOLS AND EMBLEMS

Emblematic Flowers

(Continued.)

(1)

Forget-me-not. A favorite church decoration.

(2)

Wormwood.

Wormwood is noted for its bitter taste. It is an emblem of calamity, sorrow, extreme penitence and humility.

> " Therefore thus saith the Lord of hosts, the God of Israel; Behold, I will feed them, even this people, with wormwood."
>
> *Jeremiah ix : 15. (See also Lamentations iii : 15 and 19.)*

(3)

Grape-Vine and Wheat.

The vine is emblematic of the blood of Christ.

> " This cup is the new testament in my blood, which is shed for you."
>
> *Luke xxii : 20.*

Wheat is emblematic of the body of Christ.

> "And he took bread, and gave thanks, and brake it, and gave unto them, saying, This is my body, which is given for you."
>
> *Luke xxii : 19*

(4)

Water Lily.

Water is emblematic of purification; the lily, of purity.

Water Lily is emblematic of regeneration or purification by baptism.

Plate XCI

SYMBOLS AND EMBLEMS

Emblematic Flowers

(*Continued.*)

(1)

Annunciation Lily.

Emblem of the Blessed Virgin, meaning purity and chastity. When used in Easter decoration it means resurrection.

Passion Flower.

The passion or suffering of our Lord.

(2)

Hawthorn (constancy).

> St. Joseph of Arimathæa was the first Christian missionary to England. There is a legend, that to convince his hearers of the truth, he thrust his staff (a hawthorn) into the ground, and it at once blossomed, and has blossomed twice a year ever since. Hence, it is used as an emblem of constancy.

Pomegranate. A very old and much used emblem of the Resurrection. Also commanded to be used on the robes of the Priests of Israel.

> "And beneath, upon the hem of it, thou shalt make pomegranates of blue, and of purple, and of scarlet, round about the hem thereof."
>
> *Exodus xxviii: 33.*

(3)

Oak (strength).

Ivy (faithfulness and dependency).

(4)

Palm (victory and righteousness.)

> " The righteous shall flourish like the palm-tree."
>
> *Psalms xcii: 12. (See also Revelation vii: 9.)*

Olive (peace).

> "And the dove came in to him in the evening; and, lo, in her mouth was an olive-leaf, pluckt off."
>
> *Genesis viii: 11.*

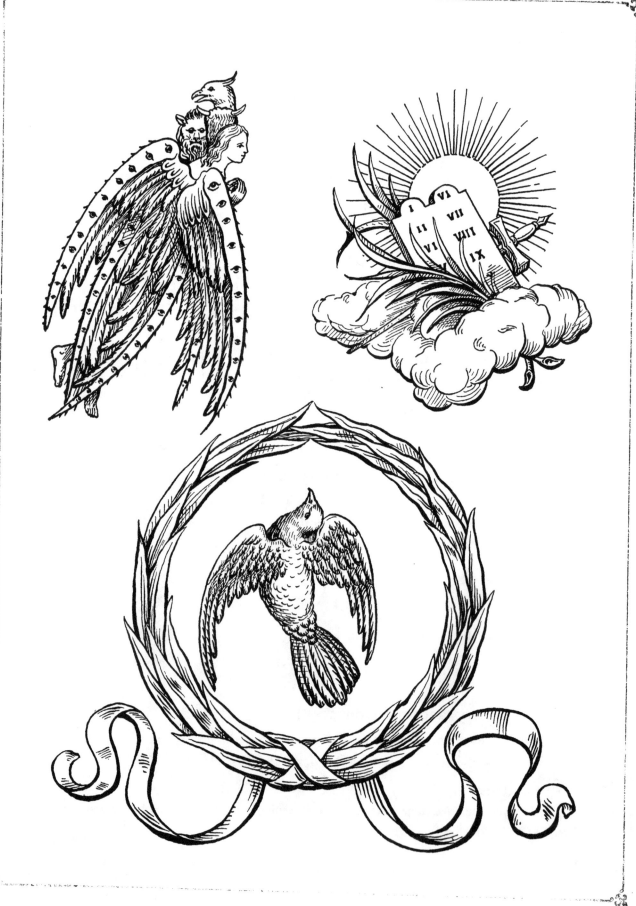

(I)

Tetramorph, the union of the attributes of the four evangelists in one figure. The wings are covered with eyes, typical of instantaneous action.

See Ezekiel i.

(2)

A combination of the Law, Sword of the Spirit and Faith.

The clouds represent doubt and obscurity; the palm, victory.

The clouds overlie or obscure the palm of victory and the table of the Law, which rests upon the sword of the Spirit (which is the Word of God). Over all is the sun (the source of light), emblematic of Christ and the Resurrection.

(3)

Ascension.

The ascending dove, surrounded by the wreath of palm, represents the victorious ascending Spirit.

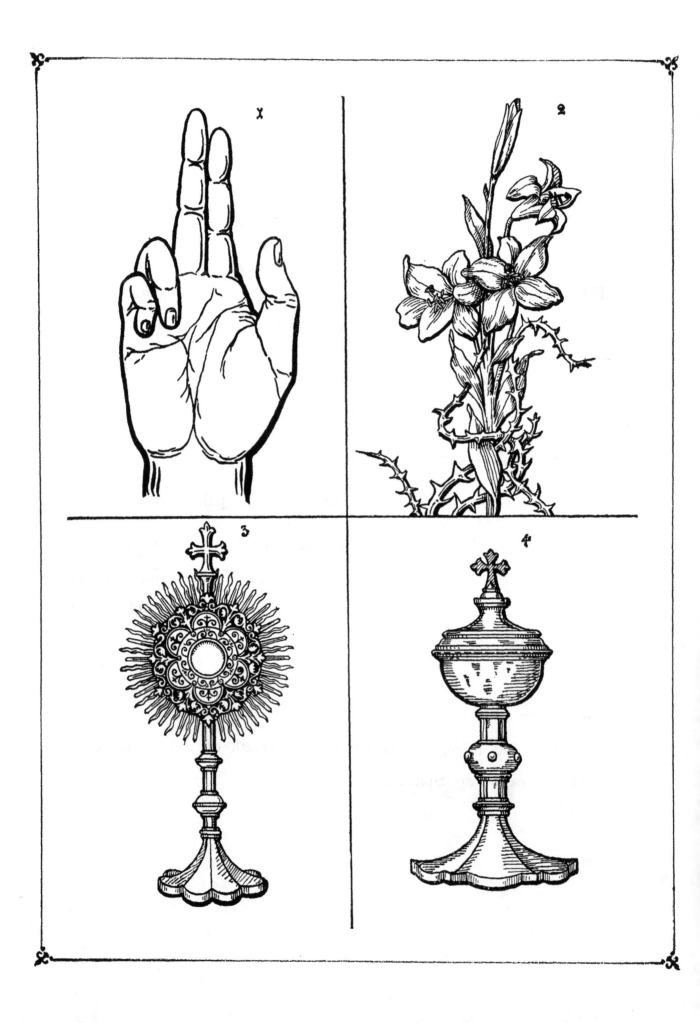

Plate XCIII SYMBOLS AND EMBLEMS

(1)

Form of Benediction, in Latin, Episcopal and various other churches.

> The thumb and first two fingers being elevated are said to represent the three persons of the Godhead, the Father, Son, and Holy Spirit. In representations of the Godhead the open hand represents salvation for all.

(2)

Combination of Lily and Thorns.

> The annunciation lily is used in this illustration, but the lily of the valley is probably most frequently used.
>
> " As the lily among thorns, so is my love among the daughters."
>
> *Canticles ii : 2. D.*

(3)

Monstrance or Ostensory. Any receptacle containing sacred relics that are on view.

> Latterly restricted to glass-faced or transparent shrines, in which the consecrated host is presented for adoration in procession, or while on the altar.

Reliquary, a repository for relics generally small enough to be carried on the person.

Phylactorium, a portable reliquary. Phylactory, in Jewish antiquity an amulet consisting of strips or a strip of parchment inscribed with texts from the Old Testament.

Pyx, vessel in which the reserved Eucharist is kept. It is made in a great variety of shapes.

(4)

Ciborium. A metal pyx, chalice-like in shape, with a dome-like cover.

> Also, a vessel containing the pyx, or the sacred wafers, or consecrated bread.
> Also, a cupboard in the wall used for the same purpose.
> In the middle ages the vessel in which the sacrament was kept, was called a columba, and was of precious metal. It stood on a platform before the high altar, and was generally made in the form of a dove.

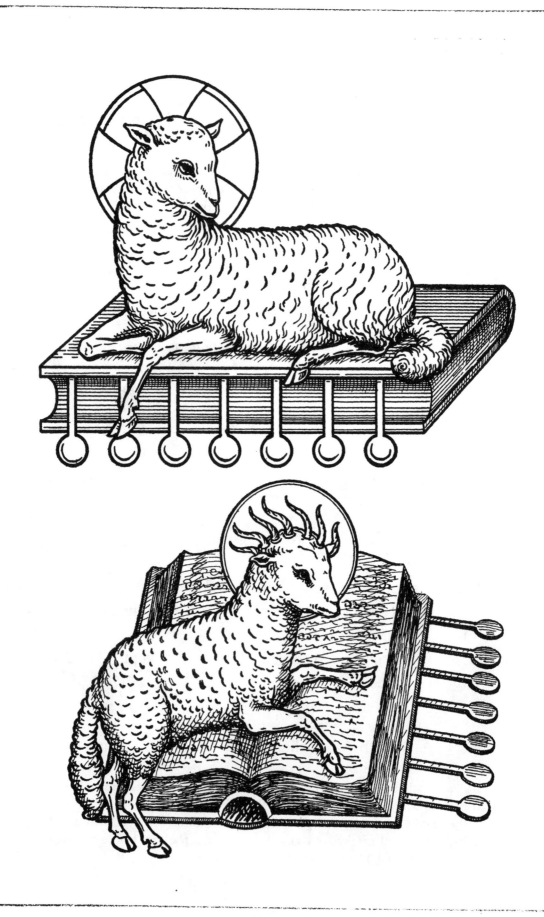

Plate XCIV SYMBOLS AND EMBLEMS

The Lamb of God and the Book with Seven Seals

"And I saw in the right hand of him that sat on the throne a book written within and on the back side, sealed with seven seals.

"And I saw a strong angel proclaiming with a loud voice, Who is worthy to open the book, and to loose the seals thereof?

" And no man in heaven, nor in earth, neither under the earth, was able to open the book, neither to look thereon.

" And I wept much, because no man was found worthy to open and to read the book, neither to look thereon.

"And one of the elders saith unto me, Weep not: behold, the Lion of the tribe of Juda, the Root of David, hath prevailed to open the book, and to loose the seven seals thereof.

"And I beheld, and, lo, in the midst of the throne and of the four beasts, and in the midst of the elders, stood a Lamb, as it had been slain, having seven horns and seven eyes, which are the seven Spirits of God sent forth into all the earth.

" And he came and took the book out of the right hand of him that sat upon the throne.

"And when he had taken the book, the four beasts and four and twenty elders fell down before the Lamb, having every one of them harps, and golden vials full of odours, which are the prayers of saints.

" And they sung a new song, saying, Thou art worthy to take the book, and to open the seals thereof: for thou wast slain, and hast redeemed us to God by thy blood, out of every kindred, and tongue, and people, and nation;

"And hast made us unto our God kings and priests; and we shall reign on the earth.

"And I beheld, and I heard the voice of many angels round about the throne and the beasts and the elders: and the number of them was ten thousand times ten thousand, and thousands of thousands;

" Saying with a loud voice, Worthy is the Lamb that was slain to receive power, and riches, and wisdom, and strength, and honour, and glory, and blessing.

"And every creature which is in heaven, and on the earth, and under the earth, and such as are in the sea, and all that are in them, heard I saying, Blessing, and honour, and glory, and power, be unto him that sitteth upon the throne, and unto the Lamb for ever and ever.

"And the four beasts said, Amen. And the four and twenty elders fell down and worshipped him that lived for ever and ever." *Revelation v.*

Plate XCV SYMBOLS AND EMBLEMS

Papal Arms of Pope Leo XIII.

The meaning of the motto is "Light in Heaven."

The Pope's arms change with each incumbent of the office; being a combination of the Papal arms and the arms of the new incumbent.

As Bishop of Rome, the Pope wears the mitre, and as sovereign he is crowned with the tiara.

> Innocent III. wrote, " The Church has given me a crown in sign of my temporal office, and in token of my spiritual functions she has invested me with the mitre; the mitre for the priesthood, the crown for the kingship, constituting me thereby the vicar of Him who bears upon his robe and upon his thigh ' The King of Kings and the Lord of Lords.' "

At present, and from the end of the sixteenth century, the Cardinal Deacon, who places the tiara upon the head of the new Pope when he is enthroned, pronounces the following words:

> " Receive this tiara, adorned with a triple crown, and know that thou art the father of princes and kings, the ruler of the world, and the vicar on earth of our Saviour Jesus Christ, to whom is all honor and glory, world without end. Amen."

Plate XCVI SYMBOLS AND EMBLEMS

Arms of the See of Canterbury

Chief Episcopal See in England.

Az., an Episcopal staff in pale ar., and ensigned with a cross-patée or, surmounted by a pall of the second, edged and fringed of the third, charged with four crosses, formées-fitchées, sa.

(Az., Blue. Ar., Silver [White.] Or, Gold. Sa., Black.)

The Mitre (Bishop's hat), the sign of the Episcopal authority, cloven to represent the tongues of fire.

The Episcopal Church in the United States has its succession from the Episcopal Church in England (Church of England). Nearly every diocese in this country has its own arms or seal.

Plate XCVII SYMBOLS AND EMBLEMS

(1)

Crozier. A Bishop's staff.

Sign of pastoral authority or care.

> They are made in an almost endless variety of styles, and are about five feet
> in length. Generally, that of a bishop ends in a hook or curve; that of an arch-
> bishop, in a crown or crucifix. They are often works of art, and enriched with
> costly jewels; when ornated with symbols, they ought to conform with the title
> of the church.

(2)

Seal of the Presbyterian Church.

For a central device the figure of an Open Bible displayed upon a
circular field, and in form as represented upon the seal of the
Westminster Assembly of Divines, upon the dexter page thereof to be
inscribed the motto "The Word of God" within an oval field, and upon
the upper margin of the said page the scriptural reference, "1 Peter i:
23." Upon the opposite or sinister page, within a similar oval field, the
following device, namely: The figure of a brazen serpent suspended
from a cruciform pole uplifted within a wilderness, in form as represented
upon the official seal of the Trustees of this General Assembly.

> In addition thereto, upon the background of the field and behind the central
> figure, a miniature of the emblem upon the seal of the Kirk of Scotland,—namely,
> a burning bush within a radiating circle of rays of light; further, a decorative
> wreath of palm upon the lower margin of the oval field, and in corresponding
> position upon the upper margin, the motto, "Christus Exaltatus Salvator," and
> upon the upper margin of the page itself, the Scriptural reference, "John 3: 14."
> In addition to this central emblem thus differenced, it is directed that a semi-
> circular wreath of branches of palm, in form, as nearly as may be, like the decora-
> tive wreath upon the Westminster Assembly seal, be placed upon the upper mar-
> gin of the circular field, and in corresponding position below the book, a wreath
> of olive and oak combined. Further, that there be placed behind the book and
> the wreath radiating rays of light filling the vacant spaces of the field.

Surrounding the whole device the scroll of the seal shall bear the
words, "Seal of the General Assembly of the Presbyterian Church in the
United States of America." (From the Minutes of the General Assembly
of 1892.)

SINITE PARVULOS VENIRE AD ME.

Plate XCVIII SYMBOLS AND EMBLEMS

Arms of the Order of St. Augustine

Party Per Pale.

The dexter half azure (blue), charged with madonna and child (ppr). The sinister half vert (green), charged with a lion rampant (ppr). A cross gules (red) extends from centre of upper margin, a mitre from dexter side, upper margin, and crozier from sinister side, a medal pendant from base. Above the cross is a Bishop's hat (green) with six tassels on each side.

The motto means: "Suffer little children to come unto me."

An Archbishop's hat is same shape and color, but has ten tassels.

A Cardinal's hat is same shape, but has fifteen tassels on each side and is red.

Plate XCIX SYMBOLS AND EMBLEMS

(1)

Mark or seal of the Epworth League.

(2)

Mark of the Christian Endeavor Society.

(3)

Mark or seal of the King's Daughters.

Colors: background, light yellow in centre shading to deep on the edge; balance, royal purple.

(4)

Badge of same society. (Silver.)

(5)

Luther's seal, used by Lutheran churches, but has no official recognition.

Colors: cross, black; heart, red; rose, white; all outlined with gold; background, rich blue.

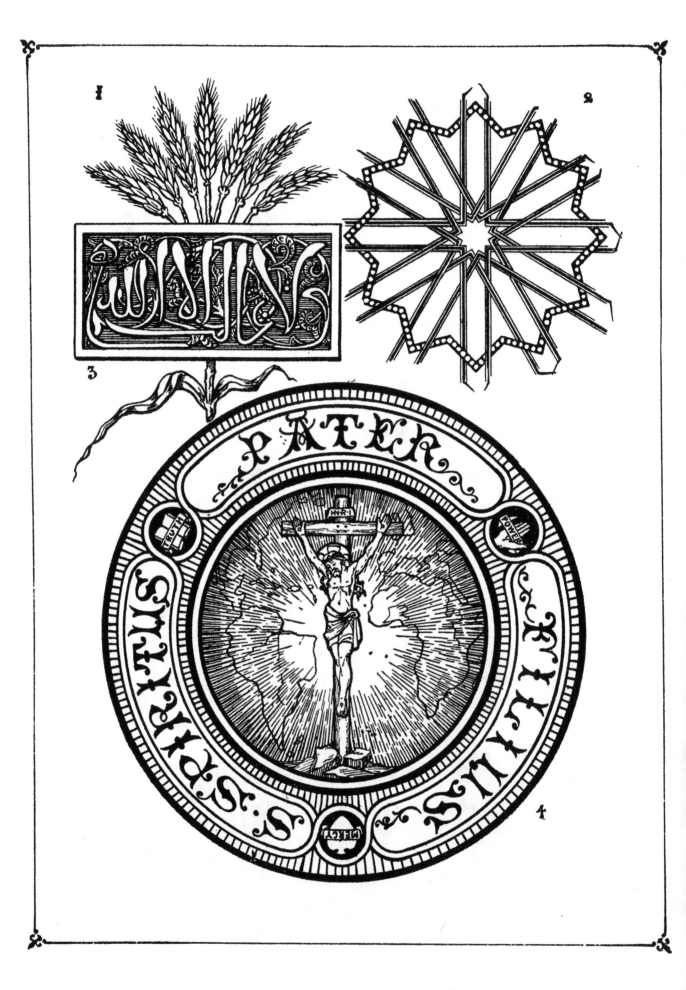

Plate C SYMBOLS AND EMBLEMS

(1)

Emblem of great prosperity (abundance.)

"And the seven good ears are seven years." *Genesis xli: 26.*
" Behold, there come seven years of great plenty." *Genesis xli: 26.*

(2)

The Star of Solomon.

This star is said to be the work of Christian artists or decorators who were compelled to embrace Mohammedanism when Constantinople was conquered by the Turks.

It was designed to show the cross, but concealed so that the Mohammedans should not recognize and forbid it; they did not object to honor Solomon.

It was the central ornament of the walls of the mosques. When the Christians were compelled to bow towards Mecca, they saw the cross before them.

(The direction of Mecca is marked by a verse from the Koran, or by a recess or niche.)

(3)

Arabic Inscription, from Owen Jones's "Grammar of Ornament."

The religion of the Moors forbade the use of symbols except the crescent, which is to them what the cross is to the Christians; it is found in all mosques in the arch of the doorways and the shape of the domes. It is called by them the sacred arch, and is known to us as the horseshoe arch.

The want of symbols was supplied by the free use of inscriptions, which attracted and held attention on account of their curious and complex involutions. The example given has been used in several Christian churches and in the celebration of great national victories, probably both on account of its beauty of design and the strength of its sentiment. " There is no conqueror but God."

(4)

Symbol of Infinite Love.

The cross, with the Crucified Christ on it, shows in the most marked manner the transcendent love of the Creator for His creatures. Inclosed in the circle it means that the love is perfect, eternal and complete; it therefore embraces the Resurrection and the Life Everlasting.

Surrounded by the Trinity, it shows that the love and sacrifice was not of the Son alone, but of the Father, Son and Holy Spirit.

The formation of the Trinity, inclosing three of the attributes of the Godhead, (everlasting truth, everlasting power, everlasting mercy) shows them inseparable. The indication of Europe, Asia, Africa, America, and the isles of the ocean, show that salvation is for all, and that the knowledge and love of Christ shall extend to all parts of the world, and that the Crucifixion was the most important event on earth.

This symbol therefore shows very clearly most of the Christian creed.

Celestial 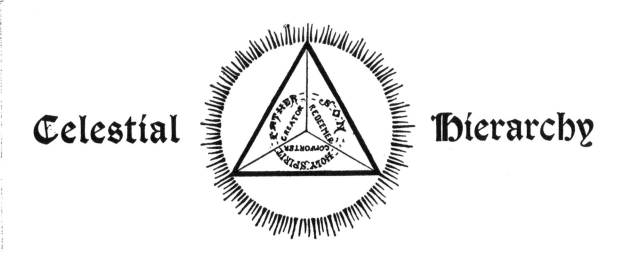 Hierarchy

Counsellors of God

Seraphim (to love), burning, glowing. Represented with six wings.

Cherubim (to know), symbol of the immediate presence of God. (See Plate lvii.)

Thrones, represented as angels carrying thrones or towers.

Governors

Dominions or Dominations, represented as angels carrying globe and cross, or triple crown and sceptre.

Virtues, generally represented as female angels in complete armor, bearing pennons and battle-axes.

Powers, represented as angels carrying a baton.

Messengers

Principalities, represented as angels holding a lily.

Archangels.

Angels.

The names of two of the archangels are given in King James' Bible, *i.e.:*

Michael (Jude 9; Rev. xii: 7; Dan. xii: 1), represented in armor conquering the dragon, or with sword and scales.

𝔐essengers—continued

Gabriel, represented with a branch of lilies, and as the bearer of the message of peace, with the olive branch. (Dan. viii: 16; Luke i: 19; Luke i: 26.)

In addition to these two, the Douay Bible, in Tobias xii: 15, "For I am the angel Raphael, one of the seven who stand before the Lord," represented with pilgrim's staff and gourd. Tradition names four others:

Uriel, represented with roll and book.

Chamuel, represented with cup and staff.

Zophiel, represented with a flaming sword.

Zadkiel, represented with a sacrificial knife.

Angels are represented according to their mission. All angels, when not in distinctive character, are sometimes represented in armor, holding swords; if not in armor, holding trumpets. But one point is very often wrong,—that is, when they are represented wearing shoes or sandals. These are of the earth, earthy. Moses was commanded: "Put off thy shoes from off thy feet, for the place whereon thou standest is holy ground." (Ex. iii: 5.)

The first to fix this order and arrangement was Dionysius, styled the Areopagite, who lived about the year 600 A.D. He is sometimes confounded with Dionysius, who was converted at Athens under the Apostle Paul.

The arrangement is accepted by many Christians.

When fallen angels are represented they are distinguished by the form of the wings, which are made like those of a bat. Also by the color of nimbus previously noted.

Index

Index

CPSIA information can be obtained
at www.ICGtesting.com
Printed in the USA
LVHW061100251020
669755LV00017B/948